PAINTING

An Illustrated
Teach Yourself Book

John Lancaster

Illustrated Teach Yourself **Painting**

TREASURE PRESS

First published in Great Britain by Hodder & Stoughton Children's Books Ltd

This edition published in 1983 by Treasure Press
59 Grosvenor Street
London W1

Text © 1977 by John Lancaster
Illustrations © 1977 Hodder & Stoughton Ltd
Photographs © 1977 by John Lancaster

ISBN 0 907812 40 6

Printed in Singapore

Acknowledgements

My grateful thanks to Hugh Collinson, topographical painter and lecturer and to
Fred Morgan, artist and art historian for permitting me to include examples of their
work; my students in the University of Bristol and Bristol Polytechnic; to pupils in
schools in Avon, Gloucestershire and Yorkshire; Michael Knight at The Hill
Residential Centre, Abergavenny and those amateur artists who have attended my
courses there; Douglas F. Lawson for his fine photographs; Winsor and Newton
and to Guy St John Scott of Binney and Smith Inc. for their invaluable assistance.

J.L. Cheltenham May 1976

CONTENTS

1 MAKING A START

Collecting
materials

In many ways primitive men and women who are to be found in the jungles of Africa, Malaysia or those who live on tropical islands in the South Pacific are really quite fortunate when it comes to 'making' and 'collecting', for most of their needs are satisfied by their close contact with the natural environment surrounding them. They only need to go outside their huts – made from straw, stone, wood, mud or animal skins – and all manner of natural materials are there for the asking. When they wish to paint, for instance, they can scoop up some soil, clay or mud, mix it with animal fats or water and they are ready to start work. Their ancestors, like our own, have done this kind of thing for many thousands of years and many of the images which they created remain to this day painted on the walls of caves, or as frescoes in temples, cathedrals and churches throughout Europe.

Collecting together for ourselves simple materials with which to start painting is quite easy and it is certainly fun to do. We can walk into the garden, if we are fortunate enough to have one, to gather up a little soil, sand or clay, while a stroll down a quiet country lane or to a building site will enable us to do likewise. We can be quite selective in choosing soils which are *yellow, brown, grey* and almost *black* so that our palette will provide us with a subtle range of tonal values with which we can work. Our searches will also reveal a wealth of natural materials which will produce dyes for us: such things, for instance, as berries, leaves and plants. But we must be careful to place each item in its own container – a plastic bag or small cardboard box will do nicely – so that it can be classified quickly and easily and so that it is recognisable at a glance when we return home. Such collecting is obviously much more enjoyable than simply walking into a shop in the high

street selling art materials to purchase an expensive range of tube colours, although we shall obviously need some of these as we progress. The same idea applies when we consider alternatives for canvas, brushes and palette knives, because old pieces of wood, cardboard and chair seats are good to paint on and we can actually apply our paint with sticks, home-made brushes, pieces of old rag or even our fingers as young children and primitive peoples often do.

Let us now take a walk down a country lane, a city street or just out into the garden and re-discover the delights which await us there. It might be wise to carry with us some plastic bags, tin cans, an old spoon or trowel and to search for some richly coloured soil (red ochre, yellow ochre, dark brown). Our collecting will have commenced in earnest. A few sticks and one or two handfuls of sand will be useful if we can find some, so that these will add variety when we come to texture some of our painted surfaces later on.

Using home-made paints

On returning to the studio – don't worry if you haven't one for many artists manage to use a kitchen table, bedroom, loft or garage floor without inconveniencing other members of the family – it might be wise to examine our finds with some care. Simple 'earth' pigments can be put into some kind of order, ranging from light to dark, or all the warm colours such as reds and browns can be placed together on a shelf or in one cardboard box or similar container. The main concern is that our materials should be identified easily as we work and so clear labelling is recommended. We shall probably find that we have a range of light fawns, muted reds or reddy-browns and a reasonable yellow or two. Some finely ground chalk will give us white, but what about black? This is where our small bundle of sticks will come in useful. What we need to do is to make a small bonfire in a bucket or old tin can and we will soon have some grey-coloured ash to give us a range of greys and a few pieces of black charcoal which we can grind into a black powder. Alternatively, we can use a little soot to make black. A bit of bacon fat, cooking oil or even margarine will prove useful as a binding medium and we can mix our colours with small amounts of one of these materials so that they are ready for use. *Young readers please be careful when using these materials so that you don't make a mess and remember to ask permission first.* We have now made some simple oil paints for ourselves and the sense of personal involvement and achievement is quite thrilling as well as being extremely satisfying.

Now that we have a range of colours we can begin to

experiment. We had hands long before brushes and it is great fun to spread home-made paints across the surface of a sheet of paper – cartridge white or even newsprint, cast off brown wrapping paper or old wallpaper will do if you can't afford good quality paper – just to see what colour effects and tonal qualities we can achieve. We can also make some simple brushes. All we need to do is to take a twig and 'fray' out the end by cutting it with a knife or striking it gently with a hammer; or, alternatively, we can roll up some small pieces of newspaper so that we produce 'pencil-like' instruments with fairly sharp points. The value of newspaper is that it is absorbent and will hold liquid paint quite well and although it isn't very durable at least it has one great advantage : it is cheap. Another method is to glue or tie bundles of hairs or bristles on to short lengths of stick and we will provide ourselves with a small collection of reasonably adaptable and brush-like tools which we should be able to use with some degree of success. We can go on to see how well these primitive painting implements behave as we paint. They might, of course, be totally inefficient or they might prove to be good, but what is important is that we have made a start from the basic fundamentals of the craft and have produced simple materials and tools for ourselves. This is an experience which will certainly give us a greater appreciation of manufactured paints and brushes later on.

Now that we have commenced it is relatively easy to think of other ways of producing more materials. Having done this many times myself as I have worked with pupils in schools, with students in college and university, and with teachers and adult groups of amateur artists, I know that this way of working can be quite successful and that it creates a most satisfying springboard for other developments.

Let us turn to the house, and begin in the kitchen. We can obtain a variety of liquids such as *cold tea, cold coffee, cochineal,* a variety of *sauces, cocoa,* etc, and we can add these to our range of earth colours. We might even mix some of them together, place them in small jars and then label them carefully so that we know exactly what to use as we work. Other rooms in the house, a garden shed or the garage might turn up some useful items as well, and we might look around for red, blue and black inks or even white typing corrector fluid from the office or study. Let us turn to the bedroom, where mothers or sisters keep their make-up jars, face creams, rouge and lipsticks and, *with their permission,* add some of these to the expanding range of very useful painting materials. As we do so our tool kit will expand and will surprise us with its range and varying qualities.

Experimental beginnings Take a few sheets of white paper. I find that a box of ordinary typing paper or duplicating paper is extremely useful because it is already cut to a standard size which is convenient and easy to use. Produce some dabs – say blue, red or green – on one sheet with the tip of one finger and gradually fill the sheet. Try spreading some areas of colour across another sheet using the fingers or palm of the hand with a 'finger painting' technique, and allow the colour to be thin in consistency. Don't worry about the mess on your hands for a little soap and water will easily remove the paint after you have finished. Now go on to produce stripes of colours with one of your home-made brushes or other painting implements. A twig will probably give you a scratchy effect; a piece of rolled-up paper will pro-duce a different one; while a ball of screwed-up rag or paper which has been dipped into watery colour and fat will produce its own and often unexpected kind of visual images. Take a piece of stick or an old kitchen knife and apply one or two extra areas of thick colour and as you do this just pretend that you are spreading butter on a slice of toast. Place some of these 'painted' marks in close juxta-position (relationship) with some of the first lines on one or two of your earlier experiments, allow the results to dry and then examine them carefully to see what they look like. Please remember, however, that all you are doing at this stage is simply experimenting with the painting materials which you have made yourself. You are pro-ducing some initial marks on a painting surface and are not attempting in any way to do what could be called *painterly* subjects. You are just finding out for yourself about the inherent characteristics and qualities of very basic paint-ing materials and in using them you are, in fact, practising the painter's craft at a very simple level even if you only do some 'dribble' paintings.

I shall assume that by now you have done quite a lot of experimental work with your home-made painting materials and that much of this will have resulted from some of the starting points noted in the previous section. The more you can find time to do, obviously the more skilful you will become and the more expertise you will acquire as a 'beginning' artist. In order to help yourself a little more with this it may be a good idea to have a simple *Work Chart* consisting of sheets of card, paper or board attached to a studio wall, on which to note down your experiences or to plot your progress (*see page 12*); or alternatively you could keep a file or folder for this purpose. You might also consider mounting selected samples of your experimental work alongside your com-ments so that you begin to build up a most useful source of reference material for future use. As this expands, it

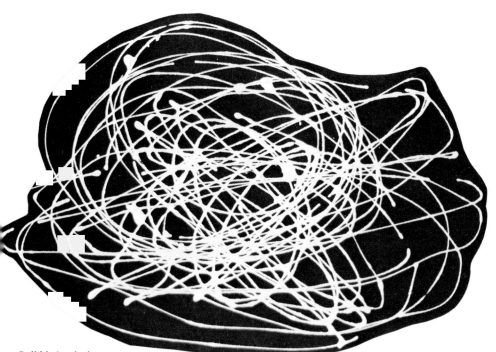

Dribbled painting produced by a simple 'Pendulum Painting Machine' consisting of a plastic bottle filled with ink or paint. Such images can be developed further by adding colours and textures with a brush.

should prove to be an extremely interesting diary of events as well as being an invaluable aid.

Texture and pattern

We must now move on to consider *texture* and *pattern*. These elements play an important part in most aspects of art and design as well as in painting. They enable the artist to obtain more visual interest than is possible by simply using plain areas of colour or tone. Perhaps a list of ideas (*see page 14*) will help, for they will encourage you to work progressively through a series of stages or, alternatively, you are perfectly free to select those which appeal to you so that you may try them for yourself. Once again, the more you explore your paints and the more varied your experiments, the better equipped you will be when you actually start to paint seriously. You must, like a musician,

WORK AND PROGRESS CHART		
EXPERIMENT AND DATE	WORK DONE	COMMENTS
1 Making own pigments (17.3.77)	This was done by mixing a dark coloured soil with a little margarine. When I mixed it with black shoe polish I produced a reasonable black pigment. A better black resulted from a mixture of soot and cooking oil.	Soil rather gritty and I should have ground it up finely with the fat. Oil in paint tended to be too readily absorbed by the paper – must remember this when I use it again.
2 Experiments with marks (18.3.77)	Smeared areas of colour over parts of a sheet of brown wrapping paper with a small piece of wood. Added lines of black paint. Added small spots of red in certain areas. This was made from lipstick.	The marks took quite a long time to dry.
3 etc.	etc.	etc.

gain complete mastery of your craft, and as you are no doubt aware, the musician will practise and re-practise his scales and five-finger exercises over and over again so that he gradually perfects his performance. In a similar way the professional sportsman will work extremely hard to reach a peak of perfection. This must also be your aim, but as you do it you should have fun. Painting is an enjoyable occupation and if we like what we do ourselves then, hopefully, others will enjoy looking at what we have achieved when they see our paintings hanging on the walls in the house or an art gallery.

I should like to go on to consider the term *texture*, which I shall define simply as *a 'surface quality' resulting from a compositional structure of very small elements.* Look at this page of print and you will see the peculiar visual effect caused by the arrangement of black letters on a white ground: *visual texture.* Run your finger over a sheet of sandpaper and you will feel the rough quality of its sur-

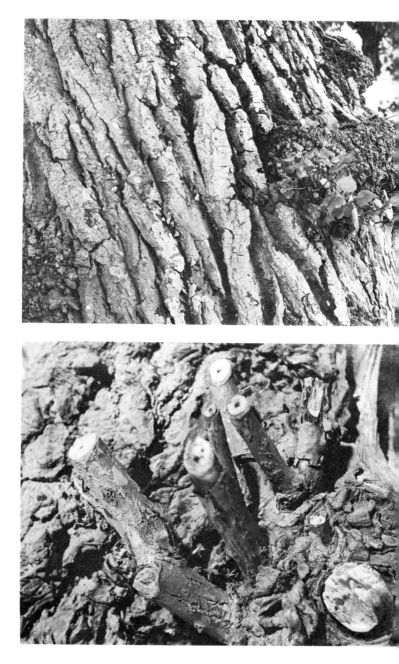

The wrinkled and cracked bark of some trees is very rich in quality. Its textured surface can be captured by means of a rubbing. Place a sheet of paper against the surface and rub gently with a wax crayon.

face: *tactile texture*. Sheets of glass, plastic, Formica or metal are smooth, while bricks or pieces of bark have quite distinct visual and tactile surface qualities or textures of their own. Now examine the back of your own hand where the skin is probably wrinkled and hairy – its own special surface texture. Look at a leaf, a flower, a piece of wood, some bark on a tree, a sheet of cork; touch a length of fabric: it will be obvious that all these have unique and exciting surface qualities which we can see or feel and which make them interesting.

Closely allied to texture is *pattern*, the main difference being that the latter depends, in the artistic sense, upon deliberate arrangement while texture is often quite randomly constituted. For our purposes, then, *pattern* will be thought of as an artistic design. Mathematical shapes or units, for instance, may be arranged in part of a painting to produce a decorative effect, and this might be seen in the pattern produced by rows of trees, wooden fences, bricks or, on a grander scale, plantations of trees in a landscape; the regular placing of stones in a wall; or the enrichment of dress fabrics. The multiple cells of a honeycomb produce pattern, as do the concentric circles where a stone has been dropped into a pool of water; or building bricks which have been stacked neatly. Of course, some patterns are also textured and we do find textures which are patterned, but enough has been said on this subject to cause us to think. Now we must experiment and I suggest that we might work through the practical suggestions outlined below:

Some practical ideas

1 Use a small piece of twig or a match-stick and cover an area of paper with dots of one colour. Don't allow the dots to touch each other although they should be placed quite close together.

2 Repeat this idea but this time use two colours.

3 Develop it further with a range of colours using a small brush as well as the wooden sticks.

This is a 'Pointillist' approach to painting i.e., a picture composed of points or small dots, and you might find that you will wish to use it when trying to achieve a special effect in a painting. It might, for instance, be a most interesting way of depicting leaves on a tree or the textural representation of flowers in a garden.

4 Take a white or yellow wax crayon and produce a series of closely related spots or lines and then paint a wash of dark ink or 'watery paint' over these. The wax will *resist* the ink or paint and you will be left with an unusual visual effect (*see the section Basic Techniques page 36*).

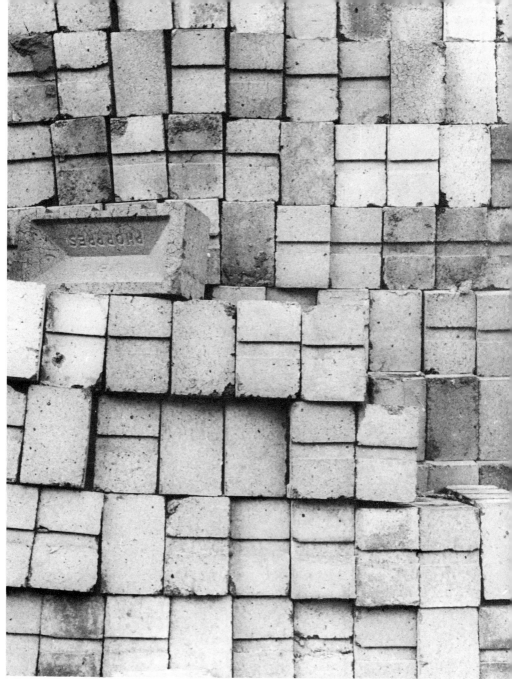

Photograph of a stack
of bricks on a building
site.

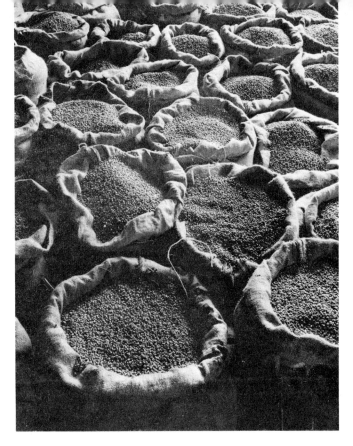

This photograph of coffee sacks by Douglas F. Lawson shows both pattern and texture. Even the sacks themselves have a texture which stems from the rough quality of the hessian.

5 Experiment with 'wax resist' methods a little more until you are satisfied that the textures you achieve are really different and exciting.

Wax resist techniques (also discussed in *Chapter 3*) may prove invaluable in producing effective skies in a landscape or for texturing the walls of buildings.

Added texture, as I shall refer to it, is always fun to experiment with and it certainly expands our painterly techniques further. When mixed with paint or inks it can actually give a great deal of visual excitement so that both we and the observer become increasingly sensitive to sensuous qualities in our own work or the paintings of great artists. One or two practical suggestions will suffice to encourage this:

a Mix some thick paint – using powder colour and glue (flour and water paste, gum, or acrylic glues) – and paint a series of small squares on a sheet of paper, card, or hardboard. Sprinkle some fine sand on some of these squares and some soil on to others before the glue has

dried. Try grains of salt, sugar, ground coffee, tea, etc. Even blades of grass and flower petals will prove to be interesting.

b Cover a small piece of card 2" (5 cm) square with glue and drop some grains of rice on to it. When the glue has dried and the rice is firmly adhering to the card you can paint over it with a thick paint. I guarantee that you will be surprised at the effects which result.

c Repeat this idea on other surfaces and look around for other interesting things which will give you raised textural effects – cotton, string, torn paper, match-sticks, leaves, cornflakes, corrugated paper from a chocolate box, etc.

The possibilities are endless. Go on to try out other ideas of your own so that you gradually build up a repertoire of ideas and skills. Remember that the more you acquire the more confidence you will have so that you will not hesitate to put them to good use when you come to work on a more advanced or even a larger scale.

Simple design composed of added textures of sand paper, wood shavings, sticky tape, etc. An experiment to discover tactile qualities.

17

2 PAINTING MATERIALS AND EQUIPMENT

The artist's choice of materials is a personal one, although he can easily be affected by the dictates of fashion, by new developments emanating from the manufacturers, or by ideas coming from the schools and faculties of art and design in Polytechnics and Universities. Many materials and equipment are obviously traditional in character and like a number of age-old techniques they have been employed for centuries. The history of painting itself has certainly witnessed many changes in painting styles and the depiction of visual imagery which was obviously affected by materials, scale, and the method of applying pigment to the picture surfaces. Medieval artists who worked on vellum[1] mixed their finely ground, good quality powder colours with honey, egg white or gums so that they would adhere to natural skins; and the many brilliantly coloured, small-scale miniature paintings which have survived in manuscript books bear witness to their craftsmanship. Fresco paintings, on the other hand, depended on the use of totally different skills in which the correct mixing together and application of plaster and pigments to expansive surfaces of walls in large buildings demanded a thorough understanding and mastery of well-developed techniques by both the artist-craftsman and his apprentices. The change from painting on wooden boards to stretched canvas, which led on to superb eighteenth-century developments in Dutch painting, was in itself one of the most significant innovations witnessed to date. Even so, the move away from chiaroscuro[2] by the French Impres-

Facing page:
Nereocystis (a seaweed).
Oil on board.
Beach scene. Abstract oil painting.

[1] Vellum – natural animal skins such as calfskin, goatskin, sheepskin and lambskin.
[2] The term chiaroscuro, generally associated with the eighteenth-century Dutch artist Rembrandt whose works are dominated by dark tones, refers to the skilful balancing of light and shadows in a painting.

sionists and their effective use of pure, vibrating colours is proof enough that individuals or groups of artists are capable of influencing artistic styles and tastes. Today, the flatness achieved by the spray-gun in abstract works of art could be considered impersonal and lacking in human feeling, for the geometric image and machine-like form have tended to dominate in recent years and abstract art has become rather mystical and detached from the non-artist who often has difficulty in understanding it.

Some artists like to work on a large scale, others on a smaller one, and this influences their choice of pigments and the techniques which they will use in achieving the best visual effects with a minimum of effort. When working on large paintings myself I have usually found it convenient, obviously depending upon the kind of textural effects I am trying to attain, to apply my colours either with a piece of rag soaked in paint and turpentine or with large household painting brushes. Even a paint roller has its uses for I have found that I can use one to cover a large surface very speedily. When, on the other hand, I have been producing small watercolours or miniature paintings in gold and colour on calfskin, I have been very careful to choose tiny sable brushes with which to produce delicate brush marks appropriate to the reduced scale and subject matter. This calls for correct selection, knowledge and skill.

Most painting materials can be purchased in local art shops, but if you wish you may write away to one or two of the large manufacturers for their catalogues. You will be able to make a careful selection from such catalogues to suit your own methods and the kind of painting you wish to do. These four companies are excellent and will cater for your needs:

Binney and Smith (USA and UK) Ampthill Road Bedford.

for drawing, printing and painting materials, crayons, chalks and Liquitex polymers. An advisory service is available and the company will organise artists' workshops (in conjunction with the local Education Authority).

Berol Ltd, Oldmedow Road, King's Lynn, Norfolk, PE30 4JR.

a large variety of materials for drawing and painting including paper, card, canvas, glue, brushes, palettes, palette knives, etc. This company also organises workshops, lectures and demonstrations on request.

Winsor and Newton,
Wealdstone, Harrow,
HA3 SRH, Middlesex.
535 Winsor Drive,
Secancus, New Jersey,
07094 USA
102 Reserve Road,
Artarmon, N.S.W. 2064,
Australia.

a large selection of artists'
materials and equipment. Also
prepared to make specially
ordered canvases ready for
your immediate use.

(Others are listed under *List of Materials Suppliers* towards the end of the book.)

Powder paints These simple paints are relatively cheap to buy and children find them easy to use. They come packaged in tins and small quantities of colour may be lifted out by means of a spoon and placed on your palette – an old plate, a baking tin or other suitable mixing dish. Some adult artists do good work with powder colours and they lend themselves as a useful intermediary between the experimental home-made paints that we have already tried out and the more sophisticated ones such as watercolours and oil paints which require a higher degree of technical skill if they are to be used well. Perhaps the following suggestions will be helpful:

1 Keep powder paints dry by storing them in tins, plastic containers or strong paper bags and place small quantities on your mixing palette as required.

2 If you wish to mix large amounts of wet, thick colour as 'ready mixed' paints, these are easily stored in jam jars or similar containers with screw tops.

3 To obtain a nice, creamy consistency you could try mixing these colours with a thin gum, liquid detergent (washing-up liquid), or PVA (polyvinyl acetate) base medium, otherwise a small amount of water is all that is required.

4 To make primitive but quite effective oil paint, add some powder colour to small amounts of refined linseed oil. Mix these together thoroughly to thin or thick consistencies, depending upon the results you wish to achieve, either with a palette knife or the handle of a spoon on a flat mixing surface, or with a piece of stick or brush in a jar or tin.

5 Pictures painted with powder colour may, when they are dry, be varnished to give them body and to help them adhere better to the painting surface.

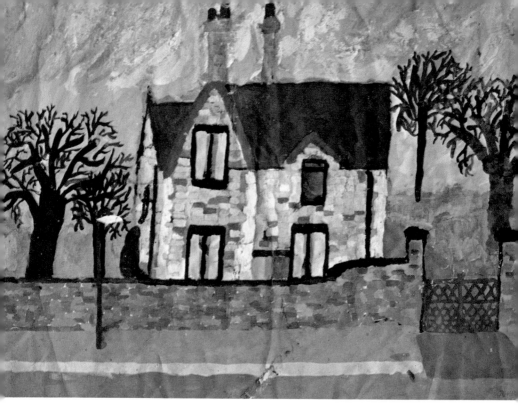

Above: *My House. A powder colour painting by a boy aged twelve.*
Below: *Abstract illuminated painting using raised gold and egg tempera colours on calfskin.*
Opposite: *Ships at Anchor. Watercolour by Fred Morgan.*

Watercolours To work successfully with watercolour paint demands a well-developed expertise and knowledge. In view of the specialist nature of this medium and the limited space available to discuss it in this book, I do not intend to look at this aspect in detail although I should like the reader to know that I have had, many an enjoyable hour experimenting with my own watercolour box. Perhaps my advice would be to 'throw caution to the winds' and just don't worry about right and wrong ways of using watercolour paints. Simply take a sable or similar brush, some colour and apply some colour washes to a sheet of white paper.

Watercolour pigments consist of ground colours mixed with Gum Arabic or other suitable gums. They are soluble in water and may be purchased in small, square pans or tubes which are usually contained in a watercolour box made of tin. The basic method used when working with such pigments is to dip a watercolour brush into water and to moisten some colour which can then be applied to a sheet of paper where it produces a transparent stain. Colours may be mixed together, of course, and highlights are obtained by leaving white areas of the paper unstained or by wiping some of the colour off with a damp sponge, rag or blotting paper. Good papers, with roughly textured surfaces, are to be recommended for these are strong and will well withstand the resultant soaking. Special effects may be obtained by dampening the paper before you paint on it, and tonal gradations will result

from the careful superimposing of colours, one on top of another, until the desired results are arrived at.

Gouache, an opaque form of watercolour paint often known as Poster Paint, can be bought in screw-top jars or tubes. It produces effects like those obtained with oil paint and is mixed with water before being applied to paper or card with a brush or palette knife. Somehow it lacks the sparkle of watercolours while drying with a matt finish and lighter tone, but it is an easy paint to use and I would therefore recommend you to try it.

Oil paints I sometimes meet amateur artists who have spent a great deal of money in purchasing large and expensive-looking oil-painting boxes containing a substantial range of tube colours. Such expense is unnecessary for tube paints alone are costly enough, and I would advise you to select your colours with discretion. If you intend to produce large-scale paintings then it is obviously sensible to buy some tins of paint. Otherwise a few tubes of colour will suffice.

Oil painting consists of the technique of applying oil-based pigments – usually mixed with linseed oil or turpentine – to a prepared ground (a board or canvas primed with a flat white) with stiff hog-hair brushes or palette knives. Such direct painting is referred to as alla prima; while another traditional technique consists of drawing on the canvas with pencil, ink or charcoal, or outlining with a brush in, say, black paint, to which layers of colours or subtle tones are applied.

The following points might be of help :

1 When you begin painting with oil colours obtain the primary colours – *red*, *yellow* and *blue* (you will have to select for yourself from a considerable range), as well as *white* and *black*. This enforced restriction of your palette will see to it that you exercise real control in mixing the exact colours as well as the exact amounts you require at any one time. I think you will be amazed at the range which is possible from these five basic colours and later, when you have developed a strong expertise and confidence in handling them, you might wish to add a few more to extend your colour-range further.

2 Keep your colours in an old cardboard box or even a plastic carrier bag. I use an old attaché case.

3 Thin oil paint is obtained by mixing your colours with spirit of turpentine. The paint can be applied to the painting surface with a rag, stick, sponge or brush.

4 To obtain 'glazed' effects you could substitute refined Linseed oil for the turpentine and apply layers of transparent colours one on top of another.

5 Thick oil paint may be applied to your painting surface by means of a palette knife. I often use a piece of card (a cigarette packet or matchbox), a plastic spatula or plastic knife as a substitute and find these to be just as good. Some artists actually squeeze the paint out of the tube (like toothpaste) on to their canvases and then work into it with a brush or palette knife.

6 Interesting textures or special effects may be achieved by mixing sand, powdered glass, straw or other materials with your oil colours as you use them. Do experiment carefully, first of all, so that you know exactly how and where in your paintings you can apply these to best effect in, for example, depicting the surface of a road, a stone wall, clouds in a sky or rough grass.

7 Note that oil paint will take time to dry, the length of time depending upon its thickness on the painted surface, and if you wish to hasten this process then you should add some specially prepared driers to your colours as you mix them.

Acrylic polymer emulsions

In recent years, we have seen the introduction of new and very interesting pigments which owe nothing to tradition. These polymer emulsions result from chemical technology and because of their versatile qualities we are able to mix them with water and use them to emulate watercolour, gouache and oil paints, and when they have dried they are durable and waterproof. They can be used extremely thinly in washes or built-up like oil paints to achieve impasto effects on almost every kind of surface, i.e., on paper, card, metal, glass, wood, canvas, brick, plaster, etc, and so they also lend themselves readily both to traditional and to new techniques. The paints are normally packaged in tubes of clear plastic so that we can see their contents at a glance, and are produced in a vast range of colours which can be somewhat confusing. If anything they tend to lack the subtle, juicy or sensuous quality of oil paint and, in consequence, some artists who were trained to use more traditional materials are critical of them. I suggest that you experiment for yourself. Try out one or two tubes of acrylic paint and see whether they appeal to you.

The manufacturers of artists' materials have spent a great deal of time and money developing these new pigments to meet the requirements of the artists of today and in consequence have turned to science. Guy Scott and Frank Birtwhistle have written about polymers and interested readers could look for their work in bookshops or libraries, or write to a manufacturer of acrylic polymers and ask for more information.

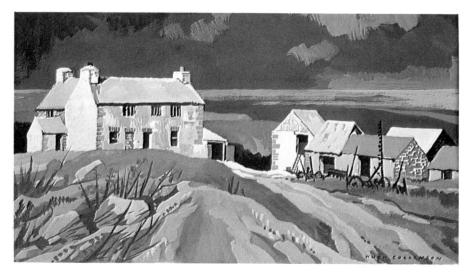

Above: *Llanwnda,*
Pembrokeshire.
Gouache by Hugh Collinson.

Below: *The Fence.*
Painted in poster colours.

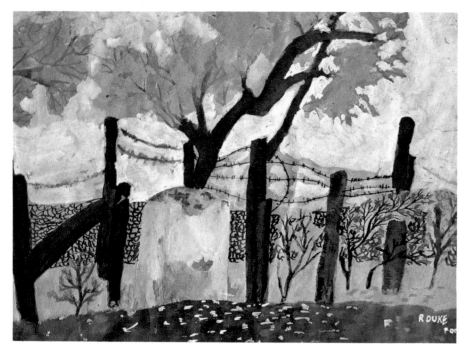

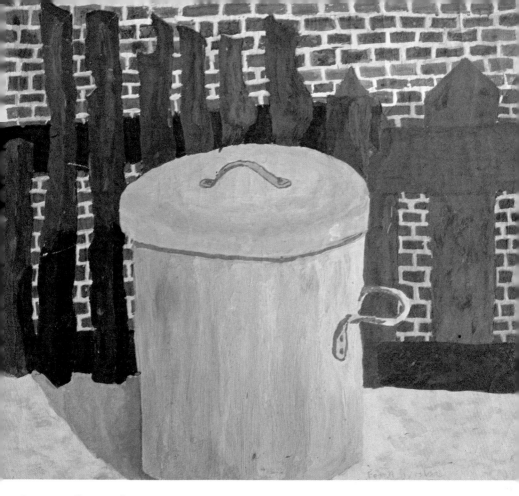

Even an ordinary wall, fence and dust bin can make the subject of a painting.

Some useful points to consider might be:

1 Polymers are produced chemically by modern manufacturing processes.

2 The most popular ones on the market have a PVA (polyvinyl acetate) base but these tend to discolour in time.

3 In general, different makes of polymer paints should not be mixed together because of the possibility of a chemical reaction.

4 Polymer binder is transparent, flexible and quick-drying and brushes must be cleaned immediately after use.

5 These paints tend to be much more brilliant in colour than some of the traditional ones and it is possible to achieve large, flat areas or colour with them as in Op art or Hard-edged paintings.

6 It is not possible to re-work these paints when they have dried and you must be aware of this point when using them.

Paper It can be quite a disconcerting experience to be confronted by a large sheet of pure white paper and I therefore suggest that it is good to start off by making a small collection of old newspapers, magazines and even wrapping paper which has been used in packaging. We can use such paper liberally in our initial experiments for as it is only 'waste' material we cannot hurt it; rather, we can only improve it. What a help! What a boost to our self-confidence! We cannot go wrong, especially if we say to ourselves, 'Everything I shall do will be right!' We can draw and paint on these materials with crayons, charcoal, inks and paints and will have no guilty feelings of wastefulness when we make a mess or have to throw them away. Later we can move on to use better quality papers.

Suggestions:

1 Old or cast-off newspapers, rolls of wallpaper, discarded wallpaper sample books, brown or coloured wrapping papers.

2 Newsprint, sugar paper (purchased in various sizes), tracing paper.

3 Typing paper (boxes of A4 size paper – white or tinted – may be obtained from office suppliers or local stationers).

4 Packets of duplicating paper (this is more absorbent than typing or Bond paper but can be useful to use).

5 White and coloured cartridge paper or specially made watercolour papers.

Card You will have noticed already that I am a great believer in experimentation and making do with the unusual. How dull it would be if we all used the same materials and followed precise techniques; nothing new would ever happen and painting would become stereotyped and dull. For this reason, I suggest that we should look around the house for old pieces of card on which to draw and paint. Card is stronger than paper and it can be exciting to use.

Suggestions:

1 Search in the kitchen for used cornflakes or soapflakes packets. If their surfaces tend to be rather greasy you can always roughen them up a little with sand-paper or even give them a thin coating of white emulsion or acrylic polymer paint.

2 If you wish to work on a large scale then you will usually find that you can obtain useful cartons from local supermarkets or household stores i.e., such things as television or refrigerator containers, tinned goods boxes, packets, etc.

3 Sheets of strawboard coated with a white 'ground' paint are also useful.

4 More refined work can be done on strong mounting boards which come in a range of colours, thicknesses and sizes, but these can be expensive.

Canvas At some stage you will certainly wish to paint on canvas, a fabric support which came into use with Giotto in the late thirteenth century, but don't be too hasty, for the making of a flexible support requires a fair degree of technical ability. You will need some strong fabric material and a strong wooden frame over which to stretch it so that you have a flat surface on which to work. It might be wise to start off by using a rigid hardboard panel or to purchase a small selection of canvas boards and to progress to the 'real' things from there so that you have a chance to accustom yourself to a textured surface first. After trying these you can then turn to *Chapter 4* where you will find a few useful suggestions, and have a go at making a wooden frame and stretching canvas.

Hardboard Unlike stretched canvas, a flexible painting support which has a pleasant, sensuous quality, hardboard tends to be somewhat hard, resistant and lacking in character. Nevertheless, it is worth using for it is relatively cheap as well as being easy to store.

Suggestions:

1 Off-cuts may be purchased at a local timber merchants and come in various sizes – large and small.

2 This material tends to be of rather an absorbent quality and should be sized and/or given one or two coats of primer before use.

3 The patterned side is rather vulgar in texture and I would therefore suggest that you use the smooth side.

4 It is worth noting that hardboard which has been given a coat of priming colour on the smooth side is good for pencil sketches, ink drawings, a mixture of coloured washes, wax-resist and ink. Barbara Hepworth, the famous sculptor, used this method to good effect in many of her sketches.

Metal, plastic and cast-off materials Polymer paints make it possible to get away from easel painting – when the artist works on a beautifully prepared and stretched canvas – for he is able to have an enjoyable and *painterly* time working on almost any material which comes to hand.

Above: *Stylized oil painting done on a farm in the West Riding of Yorkshire.*
Below: *Cathedral.* Oil on board. Demonstrating the use of straight and curved lines in pictorial composition, before filling-in with thick paint using brushes and knives.
Opposite: *Red Spots.* Detail of an oil painting in which 'impasto' effects can be seen.

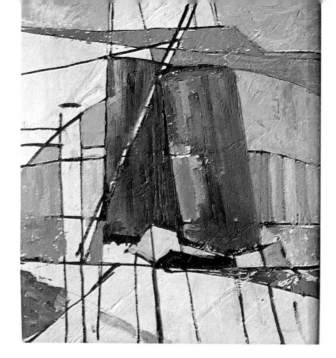

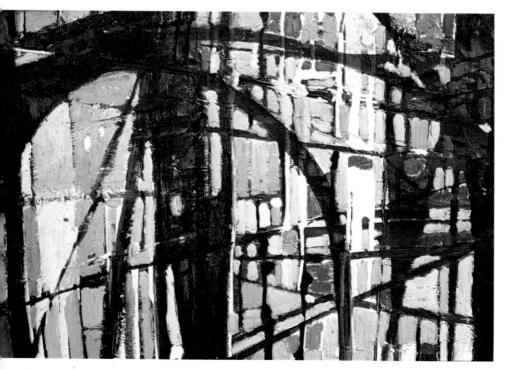

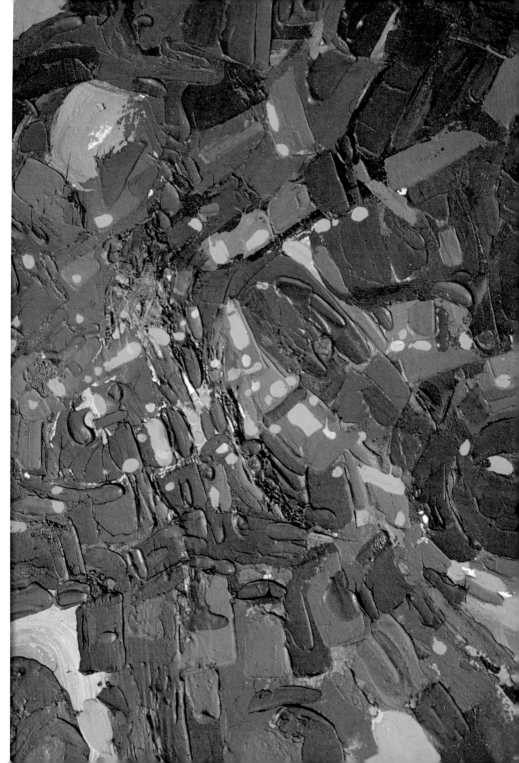

Suggestions :

1 Tin boxes or strips of metal may be painted with patterns or life-like pictures.
2 Thin sheets of plastic, glued over wooden frames, could provide useful painting surfaces.
3 Thick sheets of plastic material – obtained as off-cuts from general 'handyman' shops – are strong and excellent to use.
4 Old bottles are painted by some artists who like to experiment.
5 Look out for some old wooden chair seats or doors on which you can paint brightly coloured imagery.
6 Paint directly on to sheets of glass.

Inks Waterproof drawing inks, which can be bought in a range of colours as well as white and black, enable us to paint and draw to good effect, while Chinese Stick Ink (a non-waterproof ink) may be diluted so that we can produce washes of light or dark tones with it.

If we wish to do some simple printing, which I believe to be a legitimate form of picture-making, we should either employ some of the painting materials we already have or purchase ones which are specially prepared for this purpose. These include *water based* or *oil based* printing inks in tins or tubes, and simple finger paints. Reference to one or two catalogues will enable you to make a personal selection.

Crayons Boxes of coloured, wax crayons are always handy for quick sketches or when we wish to produce *wax resist* effects. I also like to keep a box of oil pastels as a part of my painting kit for their colours are rich and luscious. I find that I can actually work with these on polymer-based pictures to add richer colours and textured areas.

Conté crayons These hard, wax crayons in white, brown and black, are excellent for making strong drawings on a large scale. They are usually packed in boxes of twelve sticks of one colour.

Charcoal A box of charcoal is a must but you should obtain *Scene Painter's Charcoal* for you will find that it is easier to handle than the thin sticks which one usually purchases. You might like to experiment by burning some sticks of wood yourself and then use these to draw with (*see Chapter 1*). You will certainly discover that your large sticks of scene painter's charcoal are excellent for drawing on to your canvases before you start painting, for this material allows you to be extremely bold and direct.

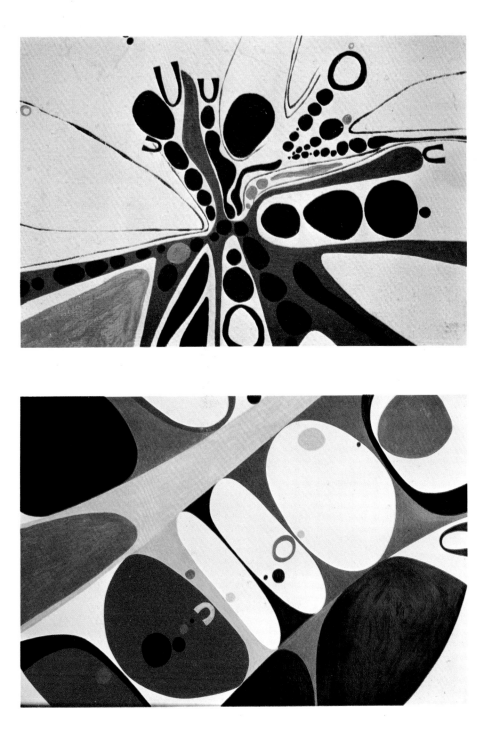

Brushes You do not require many brushes but it is wise to have a selection of shapes and sizes according to what you can actually afford. I suggest that you choose some from the following range:

1 Household painting brushes (3″, 2″ or 1″) for use in preparing painting surfaces, for large-scale work or murals.
2 Flat, hog-hair brushes (say no. 3, no. 5, no. 8).
3 Round-ended, hog-hair brushes (say no. 4, no. 6, no. 9).
4 Watercolour brushes (say no. 3, no. 5, no. 7).

Palette knives I am very fond of using palette knives. They allow me to mix my colours clearly and thoroughly on a flat mixing surface, and I sometimes employ them to apply thick colour to a painting. They come in different shapes and sizes and are made in metal or plastic. Once again it is up to you to decide what to obtain.

Suggestions:
1 An old kitchen knife can be an excellent substitute.
2 Metal palette knives are rather expensive but plastic ones can be almost as good.
3 The shapes of palette knives vary. A four-inch, flat blade is probably all you will require both for mixing your colours and applying them to the canvas, but you may wish to have a larger one as well. Some painters like small, v-shaped trowels for these enable them to apply small quantities of pigment easily. I recommend one of these for more detailed work.
4 You can, of course, always make for yourself one or two – of different shapes and sizes – out of metal, wood or bone.

Mixing palettes The romantic view of the painter is one where he holds a large, curved wooden palette on his left arm. This is fine if you have the money to purchase one. I have found such 'artistic gear' rather cumbersome, however, and tend to improvise.

Suggestions:
1 A sheet of cheap hardboard, plastic, Formica or glass makes an excellent mixing surface or palette.
2 Some painters use a slab of marble (an old wash-hand basin stand or dressing-table top).
3 Old tins, paper cups, plastic beakers, etc, are very good when you wish to mix large quantities of liquid colour.
4 Paper or crockery plates, too, are excellent substitutes for professionally made palettes.

Incidental materials

Remember to provide yourself with a few bits and pieces which may be necessary. These might include:
1 A simple smock (an old shirt will do).
2 Plenty of old rags or paper towels.
3 Containers for turpentine or other liquids.
4 Nails, hammer, pins, clips, etc.
5 Some pinboard or display space.
6 Good artificial lighting for night-time working.

Now that we have acquired a basic painting kit of materials and equipment we can go on to make a start by trying out some techniques. Some ideas are set out in the next chapter.

3 BASIC TECHNIQUES

Drawing Every artist must be able to draw so that when he wishes to make visual records of some of the objects or scenes which confront him he is able to do so quickly and easily. You, too, will need to be able 'to make marks' by *dragging a drawing implement across the surface of a sheet of paper or board,* for this is what 'drawing' means, and I would suggest that this simple definition is all we shall need to get us started. Do not be frightened by the idea, for it is easy. A number of drawing materials have been mentioned already in *Chapter 2* but I think it would be worthwhile to refer to the following ones to give you a fairly comprehensive kit with which to work: *pencils* (H, HB, B, 2B); *ball-point pens; felt-tipped pens; black or coloured inks; wax crayons; pastels; oil pastels; white or coloured chalks; black, white or brown conté crayons; charcoal* and, of course, some of your 'home-made' materials.

We are now ready to make a start[1]. Experimental mark making is fun to do and acts as a release agent so that when you draw it is with a spontaneous, uninhibited freedom. Place a sheet of paper on the floor (which it might be wise to have covered with sheets of newspaper or plastic first) and drop some ink on it. Take a stick, piece of cloth or a brush and spread the ink out in long lines, curves, circles or just large blobs. You are drawing, in a crude sort of way. Go on to use a brush and new sheets of paper and make a series of strong lines. Look around for other objects such as *twigs, pieces of wire, nails, drinking straws, pieces of cane, cocktail sticks,* etc, to draw with and make a 'large doodle'. Fill in some of the spaces with dots; add some

heavy lines; colour in some of the shapes; use a piece of wire to produce areas of thin, tracery-like patterns. Now look through the window and draw some of the things you see there – trees, buildings and sky – with some of the same drawing implements and experimental techniques.

Go on to experiment with some wax crayons. You can, as I pointed out briefly in *Chapter 1 (see some practical ideas page 14)* take a white crayon and make some strong shapes or textures with it on a sheet of white paper. Take a brush and paint some black ink over your drawing. This *wax resist* technique will give you a most interesting effect when the ink has dried. It is certainly an excellent one to use if you wish to capture the texture of a sky, some rocks, the surface of a road or the patterns of fields and it can be extremely effective if you are sketching a rocky beach or cliff. Pieces of twig or rolled-up tubes of paper may be dipped into inks or paints and make very good drawing tools. You might even try drawing with them over wax resist images where you are keen to add fine areas of detail, or go on to use them on damp sheets of paper so that the graphic images are different.

Oil pastels, though rather expensive, are very nice to draw with. They will give you painterly effects of an intense richness and depth of colour and tone, and, in my

The artist's use of a wax resist technique to achieve rock-like textures can be clearly seen in this illustration.

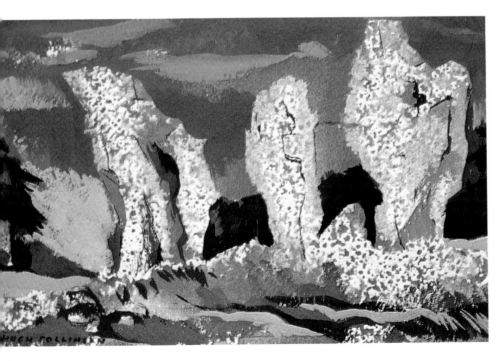

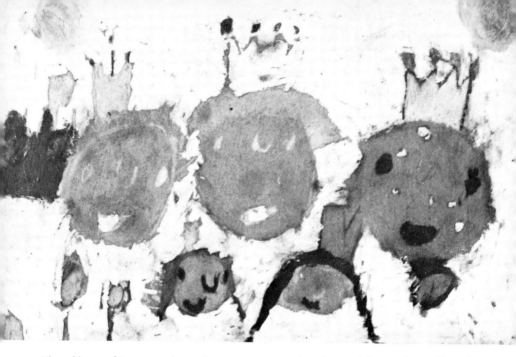

Three kings and two princes. A charming oil pastel by a young child which has a 'painterly' feel about it.

view, they are a must for the aspiring painter. Try them out and see how you like them.

Conté crayons, too, are a favourite of mine for they permit me to work quickly as I cover a vast expanse of paper with tonal contrasts. Black is particularly intense in quality although it is important to use a strong paper if you intend to work in a bold way. You can use the flat edge of a piece of conté crayon quite delicately to produce broad areas of tone; run the sharp edge across or down the page to obtain an incredibly fine line; or you can crumble some of the crayon on the paper before pounding it into your drawing with a stick or finger. Why not rub in a little water on parts of your drawing and see what happens? If you wish, add some white or black ink with a brush in those places which need highlighting.

Home-made charcoal is exciting to use although because of its primitive nature it can cause frustrations. If you have some huge sticks of scene painter's charcoal to hand you will be amazed at the results these will give you. Draw boldly with them, rub some areas with your fingers or a piece of rag, paint out others with white poster or polymer paint or erase with rubber, add black ink or paint and go on to experiment freely.

Well, you now have a number of techniques at your disposal and you will obviously add to these as you experiment. There is no *right* or *wrong* way to draw and sketch, only *your* way. Set your own standards. Draw in any way

you will and remember that you are unique, and this should be reflected in your work. Please don't bother to imitate others; just be yourself.

Finger painting

It is good to remind ourselves occasionally that human beings had hands long before they made for themselves brushes and other drawing and painting tools, and I would suggest that we should try doing some finger painting. The value of this technique lies in its directness, for we are in physical contact with our paint and the painting surface on which we place it. When we use a brush or palette knife these come between us and the images we are creating.

A piece of Formica, glass or the smooth side of a sheet of hardboard will act as a useful working surface. In *Introducing Finger Painting* (it is out of print, but you may find a copy in a library), Guy Scott points out that the kitchen is an ideal place for this kind of work. You simply spread out on a flat surface your finger paint (which you can obtain from any of the large manufacturers or make for yourself from powder colour and washing-up liquid) and then press your hands or fingers down on to clean sheets of paper. This will give you printed images which can be as simple or complicated as you wish. If you go on to draw with your fingers on the work surface, scratching some of the paint off with the finger tips, you can pull (a technical term that we shall interpret to mean obtain) what we call a 'mono-print' simply by laying a sheet of newsprint or cartridge paper on to it, and having pressed it down slightly, pulling it off carefully. Experiment further: have fun and enjoy yourself. Print-making is a form of

Intense concentration by this young artist as he works on a finger painting.

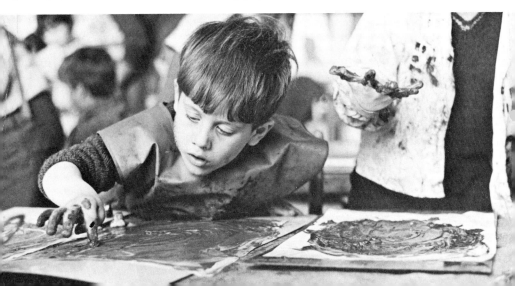

*Try working on a sheet
of paper on the floor
and make bold marks –
drawing with wax
crayons.*

painting just as it is a form of drawing, and what I like about it is that it gives you instant success. There isn't space to go into the subject in depth but if you are interested in pursuing it further there are some good books available on the subject.

Using a brush and palette knife

These painting tools are really extensions of the arm. I prefer to use a flat, household painting brush to cover large areas of board or canvas and sometimes I even try a sponge or an old piece of rag, although I have employed a small, round-headed hog-hair brush to produce dots or flecks of colour to fill in certain parts of my paintings. Hold a flat hog-hair brush in your hand as though you were about to play table-tennis or hammer a nail into a piece of wood, not as you would a pen, and you will have unrestricted freedom of movement right from the shoulder. Dip the bristles into paint and then apply this to a sheet of paper. You may work on the floor or with the paper pinned to a wall or a board on an easel, and what I suggest is that you try to make as many different kinds of marks as possible: i.e., *drag the brush across the surface; stab at it; twist the brush as you paint; imagine you are playing a drum and see what kind of marks you achieve.* Be inventive and experiment. Say to yourself, 'Everything I do is right, it cannot be wrong'. What a stimulus such thoughts are. I have certainly found them invaluable in warding off doubts and frustrations and have reminded myself constantly that new ideas and techniques must start somewhere. Why not with me? Why not with you?

Repeat these operations with different sorts and sizes of brushes and keep a carefully documented record in your work-book.

4 MAKING A FLEXIBLE SUPPORT OR 'CANVAS'

The wooden frame

It is impossible to make an absolutely first-class wooden frame on which to stretch a suitable fabric material unless you have the necessary woodworking tools, equipment and technical skills. With a little ingenuity, however, you can produce a passable one on the kitchen table, or, as I have done myself many times, on a stool outside in the garden, and having done so you may then be forgiven if you purchase ready-made canvases from one of the large suppliers. The materials required are: lengths of wood, strong glues, small screws and nails, etc, from a local handyman's shop. The size and cross-section of the wood will vary according to the size of stretcher you intend to make, but as a general rule $1\frac{1}{4}'' \times \frac{1}{2}''$ (3–4 cm × $1\frac{1}{2}$–2 cm, metric approximation) for small stretchers and $2'' \times 1''$ (5–8 cm × 3 cm) for larger ones should suffice. Glues such as Evostick, Bostik, or similar type are excellent. It is helpful to have one or two 'G' clamps, a vice and a plane, although you can make successful stretchers without the aid of such instruments simply by following a few basic instructions. These are:

1 Saw your wood into four suitable lengths: i.e., two at 20" (51 cm) and two at 30" (76 cm) or four at 20" (51 cm) or two at 20" (51 cm) and two at 53" (89 cm), etc, depending upon the size required.

2 Make simple corner joints.

3 Slot these together, one at a time, having applied glue according to the instructions, and if you have a 'G' clamp this can be helpful in clamping the joints together until the glue has set. Otherwise, a few small tacks or screws will give added strength.

4 If you are making large frames it is wise to introduce a crossbar through the centre. This can be jointed and glued into place and will help to stiffen the frame.

5 In order to expand the stretcher drive small wooden wedges into the corners.

Suitable textiles You will have to consider carefully the quality and cost of textile materials before purchasing quantities of canvas, and also whether you prefer a rough or smooth weave. To help you decide you should experiment with canvas boards, as suggested on *page 28*, for this will give you an understanding of what it actually feels like to work on a textured surface, and then you can choose from some of these textiles: *hessian* (a coarse and relatively cheap material), *jute canvas, cotton* (a finely-woven material), *sailcloth, unbleached calico* (fairly cheap but not really ideal), *linen canvas, coarse-grained linen* (an inferior canvas). Cheap substitutes are *discarded curtain material, old sacks, gaberdine from a raincoat, canvas from an old tent, deck-chair canvas, etc.*

Stretching the canvas Having made a strong wooden stretcher frame you must now cut a piece of your chosen textile material slightly larger in size than the frame itself. Place this on the floor or workbench and place your stretcher upon it. Pull one edge of the material round one side and tack it to the side or back of the frame with small tin-tacks, drawing pins or staples approximately one inch apart. If you use staples you will require a staple gun (office tacker). Having completed one side you must now pull the canvas around the opposite edge of the frame with a pair of canvas pliers and tack this into place. Repeat this operation along the other two edges, remembering to pull the canvas as taut as possible so that the tension of the canvas is even, and you should have made a tightly-stretched, unwrinkled flexible support.

Preparing the ground To prepare the ground you will need some gelatine glue, commonly known as size, a can of white emulsion or specially-made ground paint, and a flat household painting brush (2″ or 3″). Prepare the size by soaking it in cold water until all the lumps have dissolved leaving you with a glue-size solution and then give the surface of the canvas two or three coats, allowing each coat to dry thoroughly. (You can use cellulose-nitrate, shellac or resin instead of size.) This will seal the natural weave and be a good preparation for the ground colour. When this sized surface has completely dried apply *four* layers of your white ground colour, i.e., number *one* vertically (allow to dry), number *two* horizontally (allow to dry), number *three*

vertically (allow to dry) and number *four* horizontally.

You should now have a strong canvas which is as taut as a drumskin and its built-in flexibility will enable you to experience a slight give and take when you paint on it. This will provide a pleasant interaction between yourself, your brush and the painting surface.

Observational work from a red cabbage, sliced through the middle, revealing structural pattern and colour qualities.

5 SOURCES OF INSPIRATION

A dissected mackerel was used as the subject for this still-life painting.

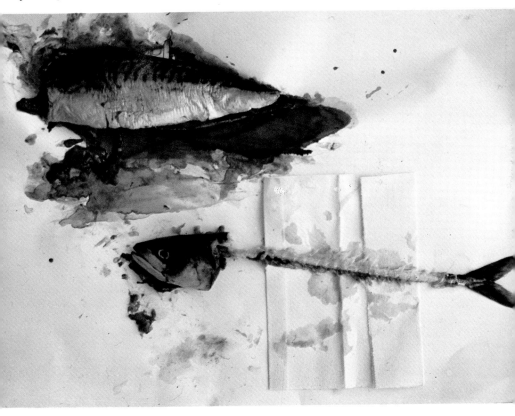

Natural forms

The aspiring amateur artist can often be over ambitious. He tends to emulate 'real' artists by painting vast areas of landscape, seascapes or views in the local town and fails to realise that the committed painter, like the professional musician, practises 'five-finger exercises' (experimental mark making and colour exercises) and narrows the field of visual interest before he even attempts complicated or large scale work. My advice is that you should limit your view of the world and focus in on a few small objects. You can take a piece of coal, for instance, and if you look at it closely you will find that it is full of interesting shapes, patterns, textures and colours. It is not simply black. Take a small watercolour brush and some watercolour, polymer or poster paints and carefully copy this object to scale. This will require a great deal of skill and precision on your part and as a 'five-finger exercise' or preliminary try-out it will help you to improve your technical competence in handling precise colour mixing, drawing, and visual depiction of its shape and form. The exercise will make you concentrate very carefully indeed and, in consequence, will train you to look and see.

You should go on to do more of this kind of work in your sketchbook or folder as well as drawing and painting other small objects with pencils, crayons or pen and ink. Collect some leaves, pieces of bark, wood, branches, stones and a few wild flowers. Slice through a red cabbage or cauliflower. When you next go to the seaside explore an area of beach for some shells, rocks, seaweed and the remains of small sea creatures, and on returning home you can draw and paint at leisure from what, by now, should be an increasing wealth of source material. As you work more and more from observation you will find your technical ability increasing accordingly.

Have you thought of asking your local fishmonger for a freshly cooked lobster or crab? Purchase uncooked ones or get him to give you a few scraps for nothing. Buy a few small fishes, a whole plaice or a kipper, and record these meticulously with your small brush and paint. If you have a stuffed bird or animal in a show-case you can do likewise, for this will give you an opportunity to look very carefully at skin, fur or feathers. Local museums are often very helpful and will probably lend you such things on request. If, however, this avenue proves fruitless I suggest you rummage around in a second-hand shop and see what you can find going cheap.

Let me stress yet again that you must train your eyes to be 'seeing' and 'thinking' eyes. You must develop a sensitive awareness to objects and this will make you much more conscious of the world around you.

Opposite: Gnarled roots, branches and pieces of bark will add interest to the working environment and be invaluable as sources of inspiration.

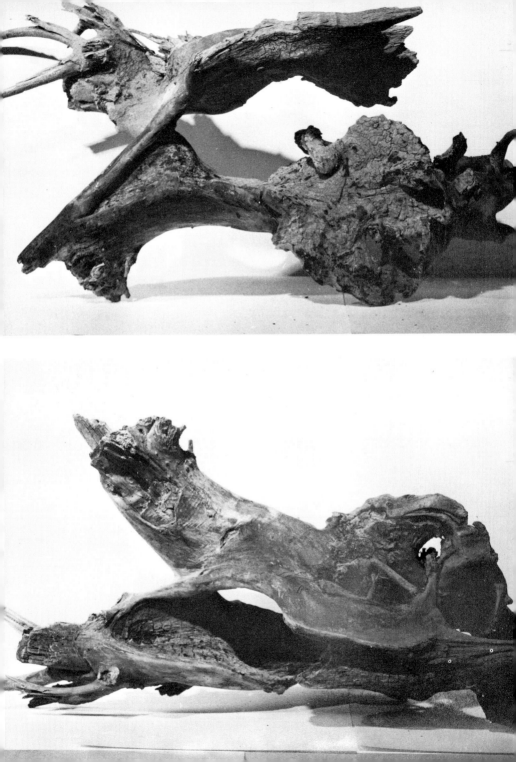

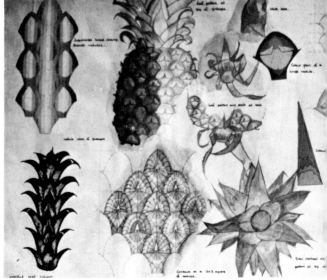

Above: *Watercolour painting by Fred Morgan.*
Below: *Sketchbook drawings based on a pineapple, by a teenage artist.*

Man-made forms

Mechanical, hard-edged objects made by man can often seem to be rather more difficult to draw and paint than many natural forms and yet we must employ them in extending our 'five-finger exercises' further. What can be more exciting than to look at an old typewriter with its keys, knobs and mechanical contraptions? Lift up the bonnet of a car; then set up your easel and paint what you can see. Discover a rickety old basket-chair or a lawn mower in the garden shed just waiting to be depicted in paint. Discarded clothes, junk or even broken windows look interesting, as do piles of books, newspapers and magazines.

You don't need to think very hard about things to paint, and you don't need to go looking for unexpected scenes which will form masterpieces. Every house vibrates with interest, both inside and out. Take an old clock to pieces and copy some of its moving parts. Use a magnifying glass to look closely at a radio or television valve and go on to enlarge your newly found images, blowing them up to a larger scale when you translate them to canvas.

The Bridge. Oil on canvas.

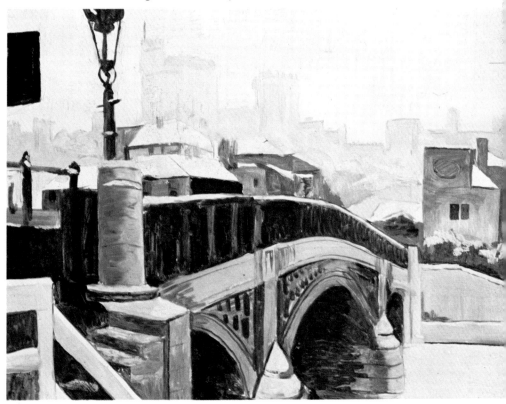

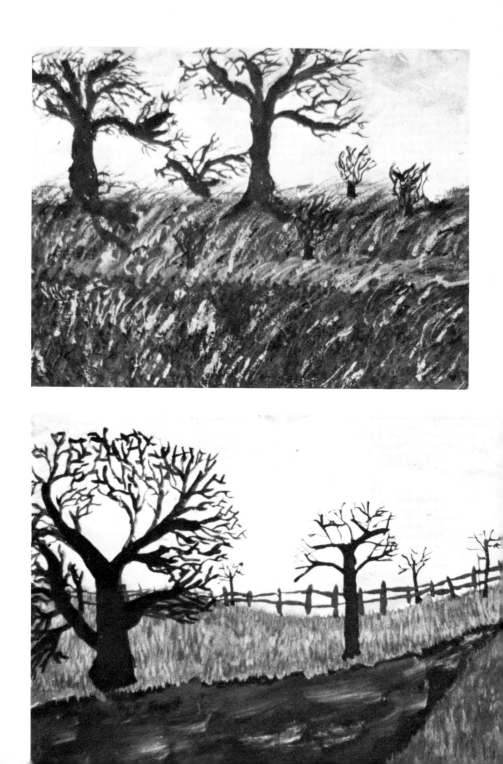

Using the countryside

The countryside, with its abundance of hills, fields, woods, moorland, lakes, rivers and farmland is a tremendously rich source waiting for us to use it. Take a trip out with a sketchbook and some materials and record a scene from it. Outline your scene with thick black paint and heavy strokes on your canvas when you develop your work back in the studio from your sketches or photographs. Landscape is both architectural and atmospheric. Try a palette consisting of black, flake white, cobalt green, burnt umber, cobalt blue, Winsor yellow, yellow ochre, vermilion and crimson. Use a brush to fill in areas of the painting with colour – you might try doing this in a darker tone than you intend the finished painting to be; now go on to lay thicker paint over these areas with a palette knife, allowing the darker tones to peep through in places so that they give the picture a crispness and added strength.

If trees are to form the basis for working, it is possible to approach the subject in different ways. One way is to consider the massing together of a group of trees just as an area of colour or tone in the landscape, and this can be done quite simply by laying the required colours down on the canvas within carefully defined shapes either with a brush or knife technique. Alternatively, it is possible to rest the drawing board on an actual branch and to look up into a tree's massive shape where the twisting branches are

Opposite: *Trees in the countryside. Painted by adolescents who used polymers.*
Below: *Storm. Framed landscape by the author, in oil paint and oil pastels, then photographed against two mirrors.*

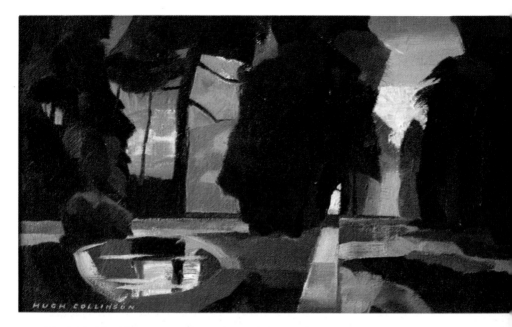

The Pool Ride. Oil painting in which the artist has used contrasting tones to achieve the required effect.

an excellent inspiration. I have done numerous tree paintings in which I stressed the straightness of parts of trunks, branches and twigs by painting them in strong, black strokes and this has enabled me to break down the plain surface of my canvases into segmented areas of pattern. After doing this I simply filled in these areas with colour. Try this way of working.

Painting the urban scene

Town and city streets vibrate with visual interest just waiting to be captured in paint. Crowded pavements are full of movement, colour, shop windows and notices, while alongside them are streets busy with cars, buses and lorries. Take a camera with you and record some of this excitement. Develop your negatives as black and white photographs and translate parts of these on to canvas on an enlarged scale. Alternatively, you can project slides on to a prepared canvas and paint direct. I am convinced that artists such as Michelangelo, Rembrandt, Klee, Gauguin or Van Gogh would, if they were alive today, use all manner of technical tricks to help them, and this is certainly quite a legitimate thing to consider. A multi-storey car park is an ideal place for stimulus with its rows of parked vehicles in all manner of shape, size and colour. Its darkened stair wells could be used in an imaginative way, or its dark shape, silhouetted against those of other buildings, chim-

neys and trees against a violent sky, could fit into a city centre scene.

What about the rows of terraced houses in a Lancashire city, the interesting valley scenes in South Wales, a small hotel in a country town? Is it day? Do we consider night with its sparkling lights? Can we find stimulation on a motorway? Take a look at the activity on a building site.

Still-life painting

Still-life work is an important and valid thing to do. I feel that too many artists scornfully ignore it as being a bit 'twee', but it can be a helpful aid in the development of painterly skills, personal ability and confidence.

It isn't wise to arrange objects too carefully, for this can produce a sterile grouping. Rather, place some objects – an old bucket, some cloth, a cast-off coat, some bricks, a few dead flowers, vegetables or a plant – on the floor or a table top and do some quick colour sketches of areas

Capel-y-Ffin Church.
Gouache.

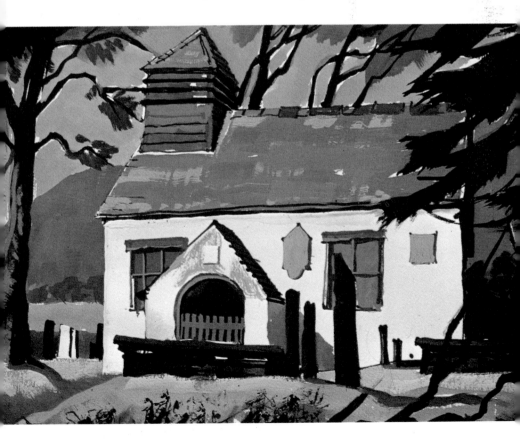

Simple watercolour by a boy of thirteen, based on sketches of a house being built. His depiction of patterned bricks and the fence give it a charming, naïve, quality.

Linear patterning resulting from scaffolding and a ladder.

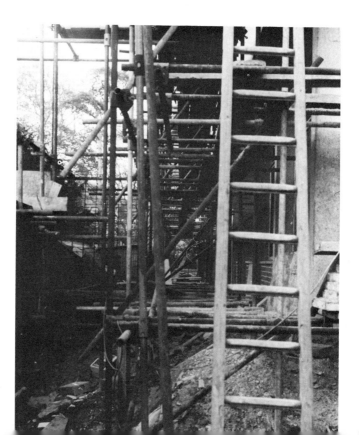

which interest you. Don't attempt to fit everything you see in front of you into your painting. Be selective and focus in once again so that the clutter or chaos is removed; and please don't worry if you only have space for a part of some objects. Let these remain and make the picture space, and the objects you put into it, work.

When you colour your still-life try limiting your colours to, say, a range of blues, with the addition of white and black. Paint a second one in yellows and browns. Do another in black, white, grey and green. Get away from reality and produce unexpected or unconventional results. You could try doing the same with vases of flowers, dried leaves or even bowls of fruit.

If you would like to be a little more inventive you might gather together a few large stones, some soil, grass and twigs. Arrange these carefully on a strong board and you will have produced a 'still-life landscape' from which to work. This is particularly useful in inclement weather when you have to stay indoors.

Other effects can be obtained if you drape Melanex (a mirror-like plastic material) behind some brightly coloured objects. This produces distorted images of the objects which can be made even more dramatic if one or two different coloured lights are directed upon them. The important thing is that this approach seems to lend excitement to still-life painting and makes it different.

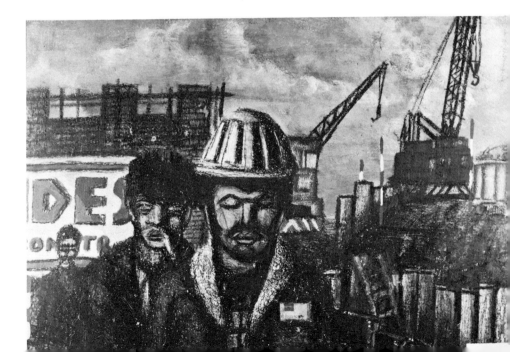

Building Construction Workers. Crayon and tempera by a teenager.

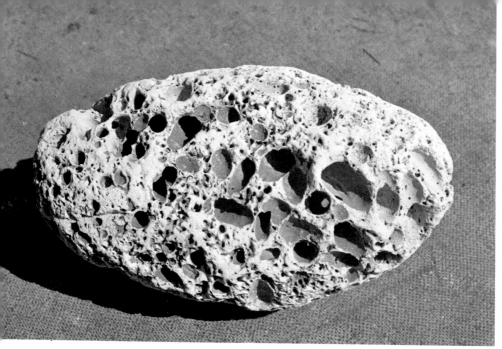

A sea-washed pebble.

Other sources of inspiration

The environment around us abounds with visual and structural imagery which, if selected carefully, can be a tremendous stimulus for the artist. We must learn for ourselves just *what* and *how* to select, however, in the chaos of our everyday world, a technique which the professional perfects in developing personal discernment.

In searching for sources of inspiration you must strictly limit the discovery area. I have, for example, found that a beach can provide all kinds of interesting things, i.e., seaweeds, rocks and pebbles of varying size and rockpools whose shapes, patterns, textures and colours have inspired me to be creative. The seashore has strongly influenced a lot of my work and I have explored beaches in Devon, Yorkshire, Scotland, Spain, Sweden and the USA in an untiring search for natural phenomena to draw and paint. Handling stones, shells and pebbles has certainly made it easier for me to record them graphically, as well as giving me opportunities to look at them carefully in producing controlled images. My own way of working means that I quickly discard objects which I have found – although I still like to have them nearby – and I work on from memory in a semi-abstract way as an 'action painter', producing colourful, calligraphic paintings, a technique that I will expand upon shortly.

We must all decide what our own approach will be and yours might be quite different from the one I have just explained. If you intend to paint a hedgerow, should you stand back some yards away from it or push your sketchbook right into its prickly midst? Prickles hurt, but in doing this you will experience the prickly nature of a hedge, which is a real, growing piece of nature, and this will imbue your work with feeling.

Take a walk in a dark pine wood and enjoy its mysterious nature. Stroll over some fields in the freezing rain. Scramble on those jagged rocks in a snow storm. In this way you will become as one with nature and your paintings will abound with atmosphere and feeling which you have experienced at first-hand. Carry a bottle of black ink with you, as I did myself one frosty winter's morning, and paint some trees as the ink freezes on the surface of the paper and a feeling of coldness will inevitably creep into your work, just as you will better capture the atmosphere of a bonfire when the tears stream from your eyes as you paint such a scene direct.

If you are a person who likes to read you will have plenty to inspire you as these short passages from George Orwell's book, *The Road to Wigan Pier*, illustrate. He was

Portrait in oils.

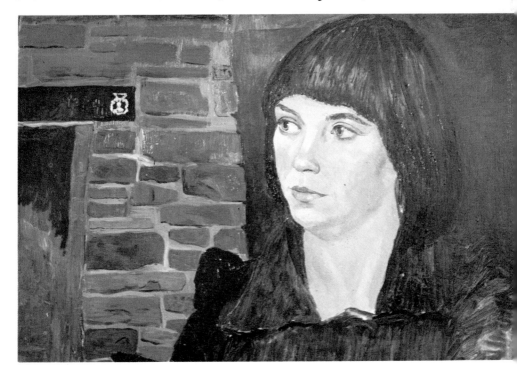

writing about the industrial environment in the north of England and his perceptive descriptions of the coal mining scene are extremely vivid:

'All around was the lunar landscape of slag-heaps ... and ... through the passes, as it were, between the mountains of slag, you could see the factory chimneys sending out their plumes of smoke ... To the right an isolated row of gaunt four-roomed houses, dark red, blackened by smoke. To the left an interminable vista of factory chimneys, chimney beyond chimney, fading away into a dim blackish haze.'

Having described the physical environment so clearly Orwell goes on to consider the actors in the scene. He continues:

'When a miner comes up from the pit his face is so pale that it is noticeable through the mask of coal dust ... (and) ... the spectacle of a shift of several hundred miners streaming out of the pit is strange and slightly sinister. Their exhausted faces, with the grime clinging in all the hollows, have a fierce, wild look.'

I have no illustration to go along with these descriptive passages but I have included them in the hope that you will be inspired to do this yourselves. You could paint, as Lowry the Lancashire artist did, scenes of mining towns. You might concentrate upon soot-begrimed rows of houses or forests of tall factory chimneys. On the other hand, you might find the idea of portraiture interests you and Orwell's vivid descriptions, like those of other writers, should be a tremendous stimulus.

Another source of inspiration is the microscope, for this instrument enables you to look closely at the enlarged images of tiny phenomena and structure. Photomicrography is an excellent means of producing such images for us, as these examples by Douglas Lawson show. They are pieces of pure pattern which could be copied, enlarged even further, simplified and coloured. What is more, they help to move us gently into the values of abstraction, a legitimate art form.

Opposite:
Photomicrographs by Douglas F. Lawson that show an enlargement of 200 times the original image. Above: *Small area of a skin of a fish.* Centre: *Cellular structure of Nepharadena.* Below: *Skin of an eel.*

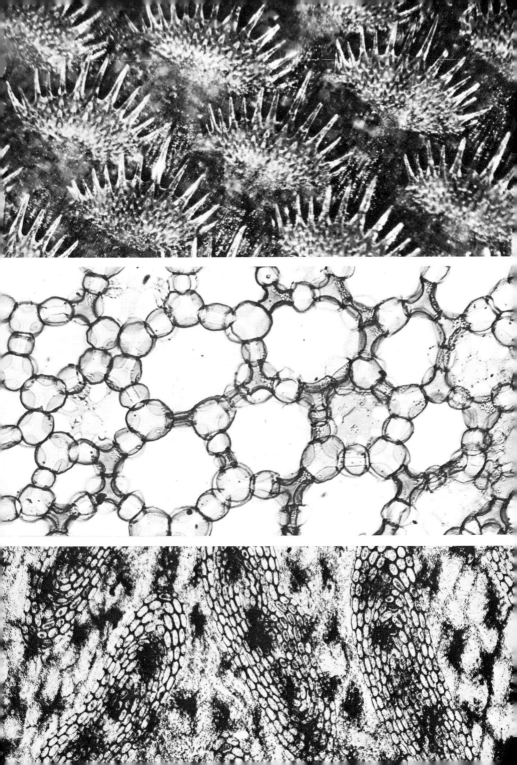

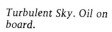

Turbulent Sky. Oil on board.

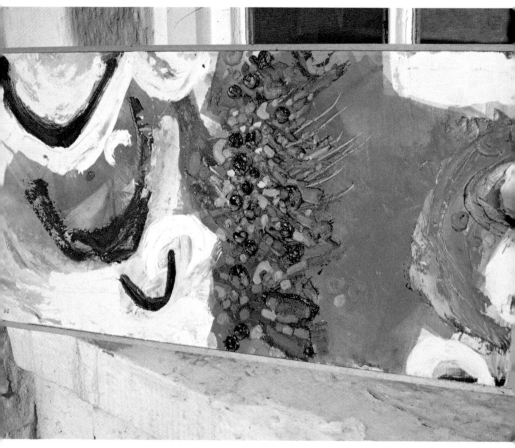

6 WHAT ABOUT ABSTRACT PAINTING?

Rock Pool. By the author, oil worked in a tachist manner. An attempt to achieve a spontaneous and exciting quality.

Some experience of drawing and painting from natural and man-made forms or, for that matter, from all sorts of environmental stimuli can be a tremendous aid to the painter who intends to develop abstraction, for it means that he is already equipped with a reasonable knowledge

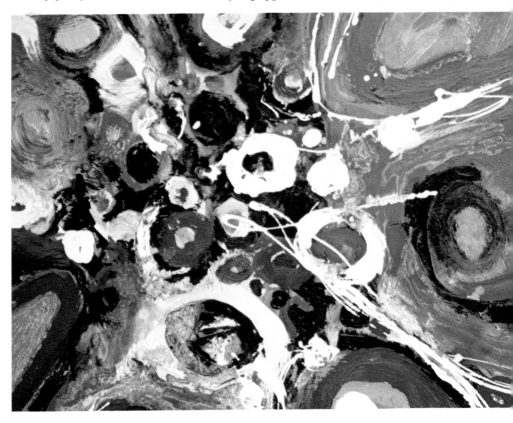

of painterly skills and techniques before he starts. If, therefore, you wish to try your hand in this interesting aspect I would hope that your experimentation with simple paints and mark making, coupled with the observational studies which you have made of natural and man-made objects or the environmental scene, will bring you to it with confidence.

How I made a start

My own initial training was as a calligrapher and illuminator. I was taught how to cut quills (flight feathers obtained from the wings of geese and turkeys) and how to use them as square-ended pens in writing script lettering on paper and vellum with black Chinese 'Stick' Ink. I also learned how to 'illuminate' my work in the traditional medieval fashion with raised gold and egg tempera colours as I mentioned in *Chapter 2*. So you see that I had a tightly-conceived and tightly-controlled artistic background in which craftsmanship was important.

When I decided to paint I found myself going into the landscape to sketch and I produced a number of countryside scenes which I gave away to friends and neighbours. I also made colour sketches in watercolours and oils of flowers and trees and developed a series of oil paintings based upon these.

The break came for me when I attended a number of painting schools organised by a group of eminent teachers and artists in the late 1950s and early 1960s. I went back to school and met Tom Hudson, Harry Thubron, Victor Pasmore (the abstract painter) and others in the group who based their teaching and methods of instruction on the ideas and philosophies of the Bauhaus, that great school of art and design which had flourished under the directorship of Walter Gropius and his team of professors – professional artists like Paul Klee and Kandinsky – in Germany during the 1920s. I began to experiment, using paint, as paint, for its own sake and not to represent natural phenomena, as I worked in a calligraphic or 'tachist' manner.

As a tachist painter I dribbled and splashed thin paint over prepared hardboard panels, cartridge paper or canvases which were laid out on my garage floor. The oil paint I worked with was thin in consistency and having soaked it into a sponge or piece of rag which I could squeeze as I painted so that I controlled its flow, I dribbled and splashed my colours over my canvases. Sometimes I worked on as many as twenty canvases at one time, moving quickly from one to another and back again to add more images or colours, and this gave my work a tremendous vitality and originality that both surprised and excited me. My paintings were lively and spontaneous and I often worked

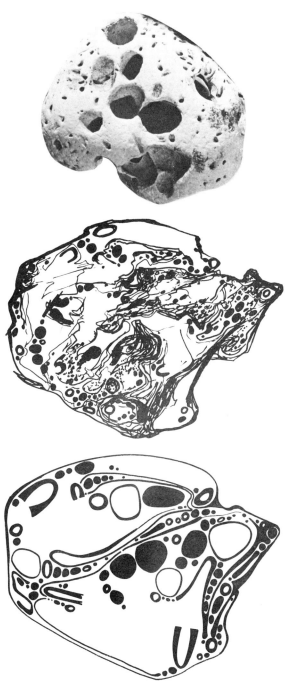

Photograph of a
sea-washed pebble
picked up on a beach
in Yorkshire. The
action of sand and
water has produced a
fascinating
three-dimensional
effect.

Pen and ink sketch of
a pebble.

Stylized drawing based
on the previous one.

to the accompaniment of music so that they tended to reflect musical rhythms and moods and became a form of visual music themselves. As one coat of paint dried I would splash or dribble other colours on to it with brushes or sticks, and I sometimes developed areas with a palette knife and thick, sensuous oil paint. Occasionally I took a palette knife or sharp wooden or metal instrument and scratched through some of the painted images to reveal the canvas or board below; or I stuck down pieces of straw, string or torn-up pieces of hessian or other materials to some areas of the picture surfaces to obtain slight three-dimensional effects. And I often restricted my palette so that this comprised, say: *blue*, *white* and *green*; *black*, *red* and *brown*; *grey*, *pink*, *orange*, *white* and *black*. The paintings done at this stage, although abstract, were also influenced to a great extent by shapes, textures and colours which I had experienced on the sea-shore. Beaches I explored provided all kinds of interesting seaweeds, rock-pools and shells which inspired some of my own work and my confidence was bolstered by the knowledge that I could use my sketches and photographs for reference.

Beach Pebbles.
Semi-abstract oil
painting.

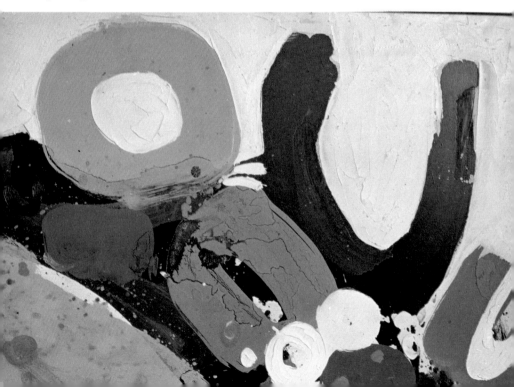

Hard-edged paintings

Although action painting fascinated me and I would have been able to go on indefinitely turning out picture after picture, there came a time when I felt that I needed to discipline myself. I found that I had to tighten up my work but I didn't really know how to do this. The answer came when I was collecting pebbles one day on a beach on the east coast of Yorkshire and I found myself looking very closely at the smooth 'Henry Moore-like' sculptures of these sea-washed forms. They contained holes of varying size where constant friction of sand and sea had caused deep penetration, grooves and coloured speckles. I could handle these objects, turning them around in my hands as I touched them, and I developed a real intimacy with them; an intimacy that is essential between the artist and the object of study.

I drew my pebbles with pencils and ink, and, having discarded them, I went on to produce enlarged images from memory. I translated these into colour, working in oils or polymer emulsions on prepared boards and canvases with a spontaneous freshness. As I worked I found that I began to modify my images, for the shapes of the 'pebble-forms' reminded me of geometry and my 'semi-abstract' paintings took upon themselves special qualities resulting from the juxtaposed forms and geometric shapes that seemed to be independent of the pebbles themselves. These paintings became 'new realities' which depended increasingly upon the interaction of inter-related circles and 'U' shapes: geometric forms which obviously emanated from those which I had discovered in the pebbles and which I used to exert dynamic pressures within each picture plane.

My work became more abstract in nature. In order to control it, therefore, I carefully planned a series of 'circle' paintings and bought a quantity of ready-made and prepared square canvases. As these were ready primed I was able to work on them at once using sketchbook drawings done on graph paper as a basis for development.

The designs themselves were of a geometric nature so I drew a grid of squares with a pencil on each canvas, identical with that of the graph paper, and then, using the centre point (in which I placed a needle to which I had attached a length of string with a pencil at the end), I drew a circle which touched the four edges of each canvas. This organisation of the painting surface into a grid of squares could be applied to musical structure in which mathematical thinking and mathematical relationships are employed and I am convinced that musical composers actually think in a similar way to mathematicians and that many abstract artists do this well. I certainly used this concept in my own 'circle' paintings. Geometric elements in

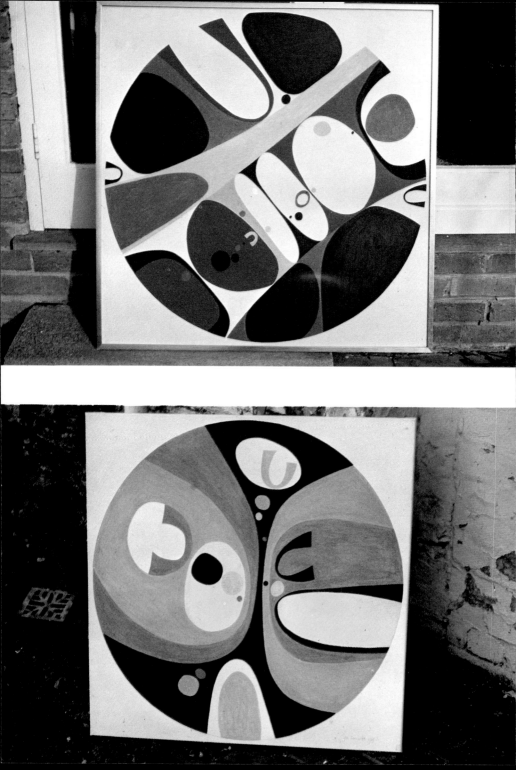

Opposite: *Circle Painting with Yellow. Hard-edged oil on canvas.* Opposite below: *Circle Painting No. 5. Oil on canvas.* Below: *Shapes. A hard-edged painting.*

these works were arrived at through the rational consideration of thought and manipulative processes, *and I accepted the geometric shapes and carefully controlled colours for what they were, not for what they might represent.* They acquired a starkness of quality as positive, hard-edged imagery. The 'O' and 'U' shapes, spontaneously calligraphic in my earlier work, became solid facets in the compositional structure of my paintings and this rhythmical, visual music was composed with a deliberation which resulted directly from my more explosive creations. Although it originally evolved from sea-washed pebbles it can be linked to enlarged cellular structures seen through a microscope. What an interesting idea that you might like to pursue.

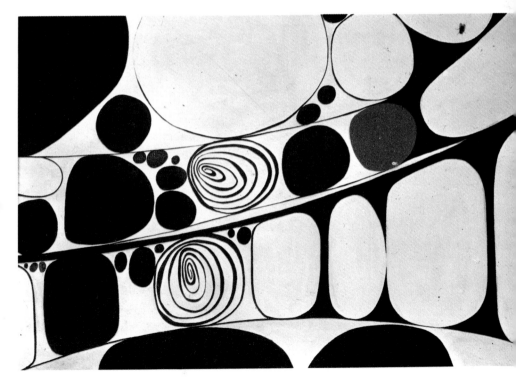

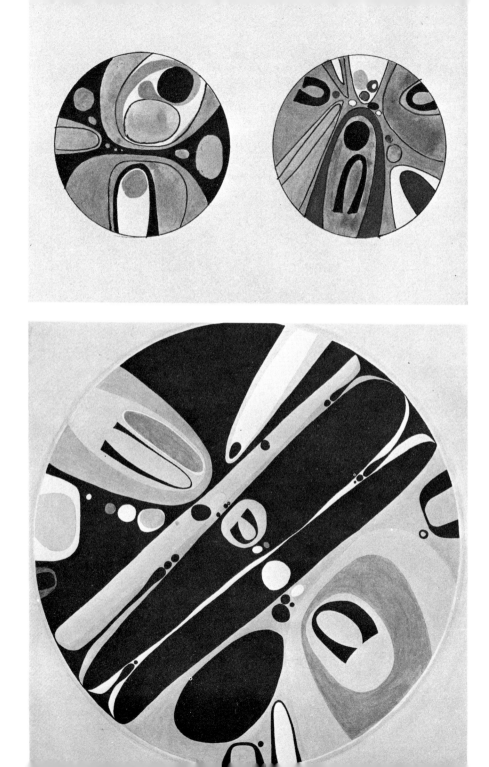

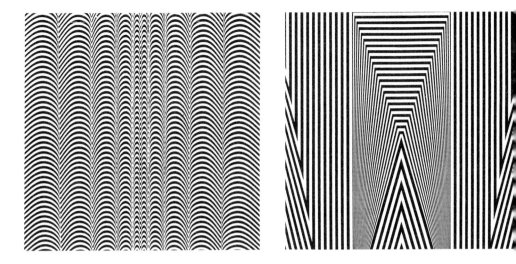

Op art This way of developing abstract imagery gave me an interest in optical art, another aspect of abstract painting, and I studied the work of op artists such as Victor Vasarely, Bridget Riley, Naum Gabo, Peter Sedgley, Jean Larcher (a young French painter) and others. In producing op art paintings these artists are concerned with dynamic, optical sensations which are evoked by flickering, black and white or coloured, hard-edged imagery. It is an art form which as I explained in my book, *Introducing Op Art*, published by B. T. Batsford (1973), explores visual movement and hallucinations deliberately created by the close juxtaposition of clinically produced lines and shapes on a ground which is, in a physical sense, absolutely static. The resulting art forms irritate and perplex our eyes and brains and so op art can be said to be the 'art of visual invitation'. Obviously this does not appeal to a lot of people but as some of you may wish to experiment with quivering optical forces – and this can be absolutely intriguing and impelling to do – the following ideas should be useful to start you off on a new and adventurous avenue:

Above: *Op Art. Paintings by Jean Larcher, in black and white acrylic paints.* Opposite top: *Preliminary designs for a series of 'Circle Paintings' using pebble shapes as motifs.* Opposite below: *Circle Painting. Oil on canvas.*

1 Carefully draw and paint a series of evenly spaced squares, rectangles or dots in black and white. Vary their size and the resulting background spaces.
2 Paint a series of black stripes from the top to the bottom of your canvas, sheet of hardboard or sheet of paper. Space some of these out evenly but set others very close together.
3 You can develop idea two further by introducing very fine lines and by placing some of the stripes at angles.

4 Try a more complicated black and white line painting with the title 'Flashes of lightning'. If you wish you could try another painting technique for this by laying down on your canvas strips of paper or card and then spraying black paint from an aerosol paint container over the whole picture surface.

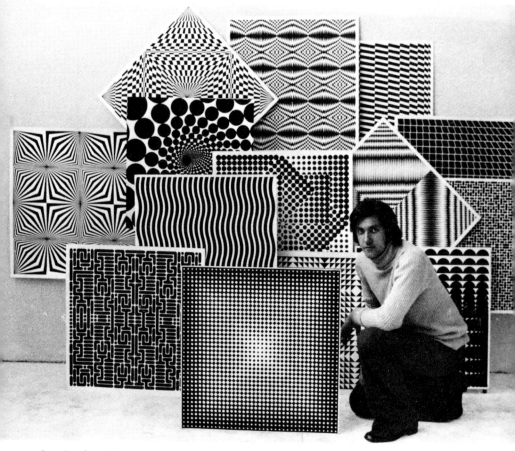

Jean Larcher with a selection of his paintings.

7 THE STUDIO

The Peyto Arch,
Chesterton,
Warwickshire.
Gouache by Hugh
Collinson.

The professional painter earns his living by producing, exhibiting and selling his work and it certainly helps if he has a well-planned studio. Just like the local bank manager, accountant, teacher or tradesman he will devote a considerable proportion of the day to thinking out his ideas.

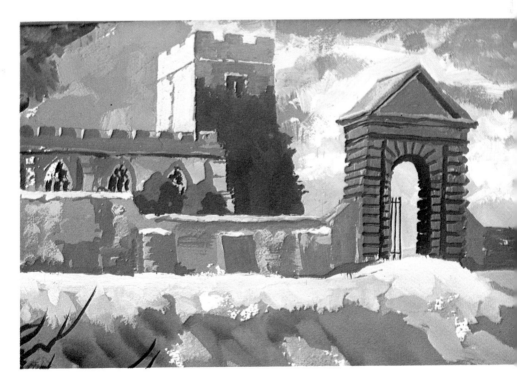

He will obtain resource material in his sketchbook or by means of the camera, go on to prepare his pigments and canvases, and then he will actually paint. To do this he needs space and a fair degree of comfort, although these requirements obviously vary from person to person, and his workshop must be well organised and functional. Amateur painters, *you and I*, living as we do in small flats in high rise buildings in or near to city centres or in semi-detached houses on estates, are not so fortunate. A studio or workshop is a luxury and we often have to put up with a converted bathroom, a kitchen or a small bedroom; indeed, one series of paintings which I produced were done in my rather chilly, draughty garage and others have been painted on a bedroom floor.

Planning the workshop
The following points are for those of you who can afford to have a studio. Let us assume that you have at your disposal a middle-sized bedroom, or ground floor study which you can convert into a studio and that you intend to spend a little time, effort and money on it before you begin to work in earnest. I would suggest that you empty it completely and then think very carefully before planning your strategy. These pointers might be a useful guide :

1 *The floor.* Hardboard sheeting makes a good covering as it can be fitted easily. Cut it to size and then tack it down to the existing floorboards so that it is quickly removed if you have to move house. This material readily absorbs spilled paint, oils or spirits of turpentine. Rush matting or a cheap cord carpet are useful substitutes if you desire a degree of comfort, although bare floorboards are obviously excellent.

2 *The walls.* I like to have at least one wall on which to pin sketch notes and paintings, and if you wish to do like-wise then I suggest that you purchase some sheets of Daler Board from a builder's merchant. You simply cut these boards to the required size and proportions and attach them to the wall – or to every wall in the studio – with masonry pins so that if you wish to remove them this can be done quite easily. For a more permanent job plug the wall first and screw the boards to it. Some artists like to have their studio walls painted white but I have often introduced a little colour (*dark green, dark blue, black* or *purple*) in order to add visual interest. This is purely a matter of personal taste and you will have ideas of your own. When you have done some paintings you might frame a few nicely. Mouldings come in all shapes and sizes and if you can afford to it is well worth-

while to spend a bit of money, time and effort in framing half-a-dozen of your works to hang on your studio walls. This will demonstrate your concern for standards while adding a touch of professionalism.

3 *The lighting.* A large window is a necessity and I don't think you need worry too much whether it faces north, south, east or west. I know that when I was at secondary school my art master pointed out that studio windows should face north, and yet I have heard this disputed by others who insist that they should collect the western light, certainly not that emanating from the south, and so on. Sometimes beggars can't be choosers and we just have to be satisfied with what comes. Skylights are excellent for they allow us a little more unbroken wall space, and in this respect you can consider yourself fortunate if you have an attic.

Artificial lighting is important, of course, but strip lighting is best avoided because of its constant, almost subliminal flickering. What you need are one or two adjustable lamps which you can move around the room easily and I have been extremely satisfied with the Anglepoise type – expensive but very good.

Dual purpose Radial Easel designed for studio use.

4 *Furniture.* You will probably require a table to work on, some wall shelves or an old chest of drawers in which to place your materials and small equipment, a stool, and an easy chair in which to sit to think or relax. Then you must consider purchasing a 'studio' easel (two if this is possible) and I recommend the Dual Purpose Easel which is sturdy and compact. This is a matter of personal choice, while depending to a large extent upon the amount of money you wish to spend. A local artists' colourman will advise you on this matter or you can, on the other hand, consult some of the catalogues supplied by large manufacturers (*see page* 92). Of course you can improvise by attaching your canvas to wall brackets. This method tends to be somewhat clumsy and restrictive and I prefer to paint with my canvases flat on the floor or propped against the wall on low tables or chairs. The most important thing is to be comfortable when you work and to be able to adjust readily the position of your canvases.

You must have a waste-box to hand; a rack for storing timber; and containers for nails, screws, and other small items. It is a pleasure to have a sink and draining board in your working area, but I have managed without such a luxury for years and find the bathroom convenient. The danger here is that you might annoy other residents and should obtain permission first. Also re-

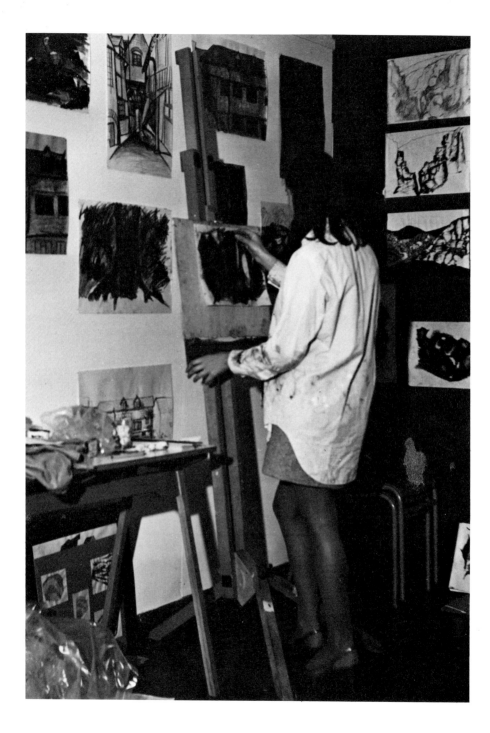

member to keep sinks spotlessly clean for there is nothing worse than oil colours for making a mess.

Creating an ethos

I have mentioned briefly that your studio walls can be used for displaying work. This is crucial in creating a lively visual environment which will reflect your interests and personality. Go into any artist's studio and you will find pieces of natural form – rocks, shells, grasses, twigs, plants, lichens and man-made objects such as old clocks, engine parts, old oil lamps, springs, coils, etc, on table tops or shelves. Pinned to the walls will be postcard reproductions of paintings, drawings and prints of the work of artists. There will be framed paintings and drawings, open books, scribbled notes, pen sketches, rubbings and photographs. Coloured and patterned fabrics will be draped as backgrounds to still-life groups, and sheets of plastic mirror sheeting will hang from the ceiling to provide interesting reflecting surfaces. A working studio needs to have a rich ethos of its own which is created by the artist working in it. Every artist is unique and the very nature of the activity demands that he be egocentric in nature. His everyday environment, therefore, which after all is an extension of himself, must reflect this and throb with an intense and reciprocated interest. This will aid the individual in pursuing original activity and inventive creativity so that the paintings which he produces will be the vehicles for his lively expressive work.

Opposite: *A young artist at work, surrounded by her preliminary drawings and colour sketches.*

8 LOOKING AT WORKS OF ART

How to look It is difficult to define a work of art and I don't wish to get involved in a long and what could develop into a futile discussion on this subject. After all it can be quite a philosophical subject and this little book is primarily concerned with the practical, 'how-to-do-it' aspect. The point I would like to make is that for our purposes *a work of art is the painting (or other art object) which stands out in a group of paintings as the one we (here I imply you) like the best*, no matter for what reasons. I have done a number of simple tests on this with groups of art students, young children in primary schools, and adults, and each group, no matter what its expertise, experience or age range invariably picked out the work of art (the most appealing artifact) from its grouping. Intuitive judgements are almost infallible when it comes to making a choice, and one invariably finds that basic criteria are involved in the creative act. These are: *balanced composition; structure in the picture plane; tonal values; use of colour; the artist's expertise in painterly techniques; good drawing*, etc, are employed.

Look at a painting and enjoy it. If the enjoyment it gives you is minimal or non-existent then move your attention on to one which you like better. Don't be a martyr to a painting and please do not follow the dictates of fashion. Find out what you like and stand by your decisions. I remember visiting the Tate Gallery a few years ago and watching a young male student who was staring avidly at a group of three black panels which were placed side by side. He seemed enraptured by these and, like a rabbit that had been hypnotized he murmured 'Marvellous, aren't they great?', in reply to my question: Why are you looking at these so intently? 'It's the thing to do, man,' he said, 'it's just wonderful.'

Why? Perhaps he was nearer to the mark than I. After all fashion changes and ideas with it. I certainly began to feel a little outdated because I just couldn't come to terms with such art. Then I walked into the Turner Galleries and there I saw what, for me, was real achievement – vision, expression, arrangement, drawing, considerable thought, creative energy, involvement and artistic skill.

So, look for what you like. Find what interests you. Your interests, likes and dislikes will change – especially in relation to your own work and control over visual ideas and forms, and your increased dexterity with materials and techniques – although you mustn't be surprised if you come full circle at some stage and find yourself back where you started.

Enjoying local exhibitions

Local art clubs tend to have annual exhibitions of their members' work and these display a tremendous amount of talent. I like to drop in to see what is going on in a district and never fail to be fascinated by the evident enthusiasm which such exhibitions exude. Try doing this. You will find the most charming pen and ink drawings; watercolour paintings of flowers and portraits; landscapes; townscapes and seascapes in abundance and all done by members of the local populace.

Painting crosses class barriers completely and it also brings together both young and old. Its therapeutic value is enormous and yet it offers a great deal to the retired army colonel, the bank manager, the housewife, and the garage mechanic in the form of commonly-held talents and interests which they can discuss together. Local art clubs allow for shared studio experiences to occur, with taught classes and visits to museums and art galleries being distinct possibilities.

Visits to large galleries

When I go to an exhibition in a London or Continental gallery I use a very simple approach. It is one that I have developed for myself over a period of time and results from my reaction to organised exhibition visits when I was a pupil at school. We had to follow a boring guide who spoke to us about every painting in sequence. But, for me, this was simply no way to see an exhibition. Watch people going into a gallery and you will see that they usually buy a catalogue, look at exhibits number *one, two, three*, and so on, and then depart. This, in contrast, is what I do:

1 I ignore the counter and do not as a rule obtain a catalogue. If I do so I don't look at it immediately, rather I look at the paintings first.

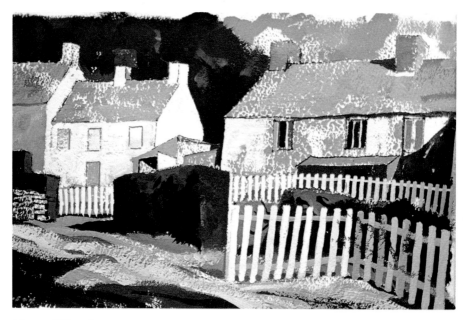

Above: *Village Fences.*
Gouache.

Opposite: *Exercise in*
perspective.

2 I walk fairly briskly through the whole of the display, trying to take in quickly what the artist (or artists) has done. In other words I imbibe the overall spirit of his work.

3 I make a mental note of two or three works which I find interesting and then return to look at these in greater detail.

4 After doing this I sometimes do another quick tour around the whole of the exhibition or go for a cup of tea so that I can look through the catalogue, and then I depart.

This method of visiting a gallery means that I get an impression of the artist's work and I am not confused. Try it and see whether you like it before developing a technique which suits you. It is important to adapt a simple *look and see* method that will enable you to find out quickly what *you* enjoy seeing.

Simple comparisons

Today it is possible to purchase excellent picture postcard reproductions in many local shops or art galleries which are relatively inexpensive. It might be useful to collect some of those which you could copy or use for reference, for a careful study of some of them will obviously increase your knowledge of the various styles of painting and the techniques which different artists employ. You might, for

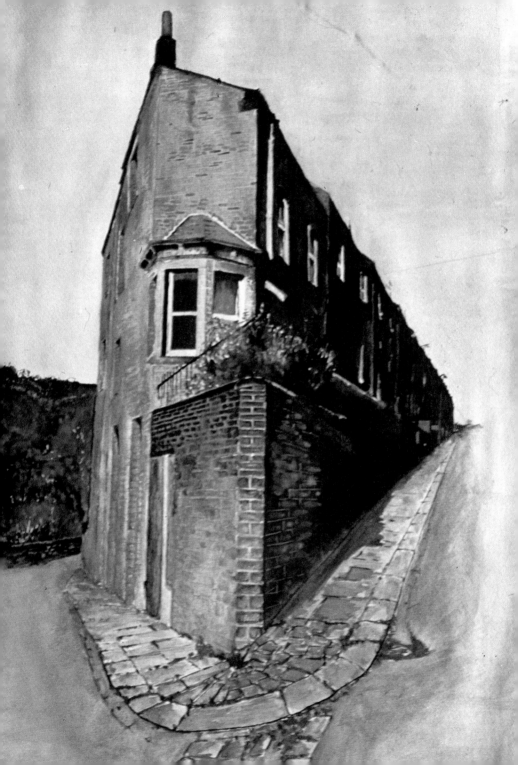

instance, concentrate upon collecting together a selection of landscape or still-life paintings, portraits or abstracts by various artists. Then you could mount these side by side on sheets of strong card or pin them up on one of your studio walls so that you can compare them. This should enable you to see differences at a glance: i.e., the way Van Gogh used brush strokes in comparison to the techniques of, say, an artist like Caravaggio; how a landscape painting by Cotman shows quite clearly how he used pure watercolour techniques (washes of colour superimposed over a darker underpainting) while, in contrast, Seurat employed a Neo-Impressionist method in which brilliantly-coloured pointillism (a dotted or broken surface) was used to fill the canvas. Delacroix was conscious of the sensuous quality of oil paint and used it to very good effect in his portrait work; Ingres, on the other hand considered an even-textured quality important and he was skilled in emulating enamelling. Work by Ingres may be compared to the detailed miniature paintings by Hilliard who used opaque water-colours on vellums or parchments in a similar way to the medieval manuscript illuminators: those earlier craftsmen who mixed finely ground powder colours with egg or gums before applying them to natural skins.

This brief commentary should be sufficient to show how useful it can be to compare paintings. It forms an interesting study in itself and there are a number of books to which you could refer. I suggest, however, that as it is a rather more specialist, historical area that you obtain the *Dictionary of Art and Artists* by Peter and Linda Murray, published in paperback by Penguin. This will be a very good introduction and its classified bibliography contains numerous sources of reference to keep you busy for some time.

9 LEARNING BY COPYING

Analysing works of art

If you wish to study and analyse some paintings you can employ the coloured reproductions noted in the previous section to good effect. They are inexpensive to buy – some can be obtained free if they arrive as Christmas or birthday cards – and you will not be over concerned if you damage some of them, especially as in the process you are enhancing your own creative abilities. I would suggest that you draw over them or even cut them into geometrically measured segments, so that you can learn more about the structural composition of paintings; i.e., the surface arrangement of colour, forms, shapes etc.

I took the liberty of drawing a grid over a landscape by Hugh Collinson (*see over*), a Leicestershire artist who works in gouache, watercolour and oils, and was interested to see that certain important features in the composition correspond very closely to the proportions and linear elements in the geometric breakdown. Please note that this geometric grid was mine, not the artist's, and I superimposed it on a black and white photograph of the painting. It is interesting, however, to note the following points:

1 The top of the church roof is on line 2 : 2
2 The lower part of the roof is almost on line 4 : 4
3 Dotted lines taken from the top of the church tower (following its roof line) go to A and E respectively.
4 The left-hand side of the church, the east-end wall, lies on line B/C : B/C.
5 A feature in the church, the right-hand edge of the door, lies on line C/D : C/D.
6 The bank follows closely dotted line 5-E.

This quick analysis shows that the artist followed a simple geometric formula as he built up his picture, and yet he did not do this consciously for when I asked him if he had

1

2

3

4

5

6

7

8

9

A B B/C

HUGH COLLINSON

C C/D D

based its construction on such a pre-determined plan he assured me that this was not so. Indeed, he was extremely surprised to see his painting considered in this way and pointed out that he had worked intuitively. This makes me wonder whether behind intuition lies mathematical order and a subliminal desire for natural beauty.

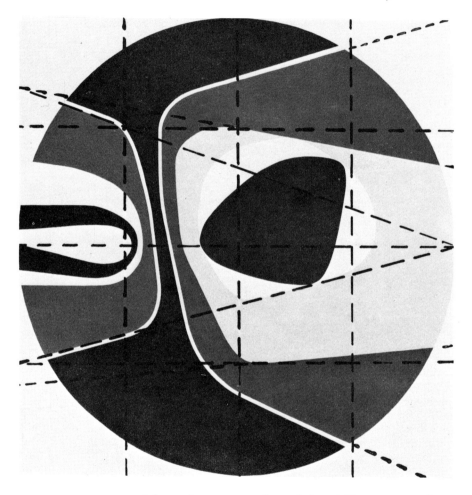

I have drawn a number of dotted lines over a photograph of one of my own 'Circle' paintings (*above*) and you can see this clearly in this illustration. In this case I had broken up the square canvas very carefully into a squared grid of pencil lines before I commenced work and it will be appreciated that on inspection it is apparent that the direction of the main dynamic forces conform to it. To

add an element of discord, however, one or two elements – such as the dark, cloud-like shape slightly right of centre – were introduced.

Now it is up to you to examine some of your reproductions in a similar way. It might suit you to work in this way, and to plan your own picture surfaces in a mathematical manner.

The way an artist has used colour and texture can also be examined. Tear or cut a small opening about the size of a ten pence piece in a sheet of white, grey or black paper which is big enough to cover a sizeable area of one of your paintings or reproductions of the work of an eminent artist. Place this over part of the work in question so that a patch of the painting is exposed and look at this closely. A magnifying glass could assist you for it will enlarge the surface qualities well. Consider rough and smooth qualities, line and colours.

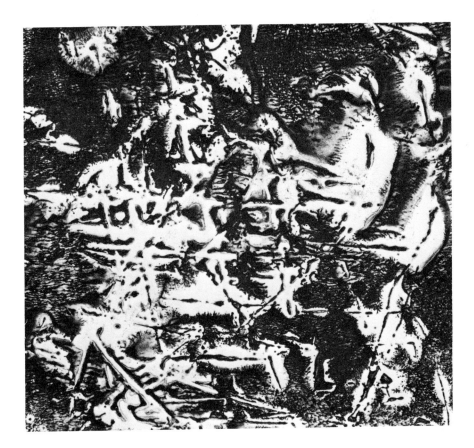

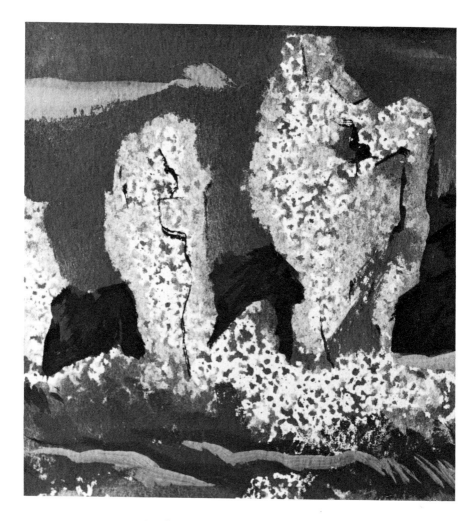

In these two examples we see how (*on page 85*) thick colour applied to the canvas and allowed to dry before colour was dragged over it with a rag, has given the artist a 'crinkled' effect. Wax resist and a wet gouache used in this detail (*above*) from a painting of 'The Roll-right Stones', another painting by Hugh Collinson in which he has contrasted areas of green, yellow and black in his design, has produced an almost accidental, rock-like effect: an effect that the artist achieved purposefully.

Focusing-in on parts of a painting like this will help to develop a keen sense of curiosity and awareness. It is a good thing to do, although I would advise you not to get too near to paintings on show in a gallery for you could get

into trouble with the authorities who, quite rightly, don't wish their exhibits to get damaged. It will help you to sharpen your vision and appreciative powers, and should expand your range of ideas and technical know-how. It should also have an effect upon your own work.

Copying You can obviously learn a great deal simply by copying paintings by other artists. This has been done throughout the centuries and is a learning process that is not to be scorned. The best method is to copy directly from original works in an art gallery and you will have to obtain permission to do this from the gallery's director. He will probably be most sympathetic to your request and will offer you encouragement.

Once you have got permission to do this then you must plan the operation carefully. You will require an easel so that you can place your own canvas near to the painting you intend to study, a painting kit, a small table and a chair or stool. Make sure that the lighting is good for it is no use hiding away in a badly lit, dismal corner because you are shy and don't wish visitors to see you. Square-up your new canvas – which might not be the same size as the original – so that you can transcribe the images correctly. To help you do this you should make yourself a simple 'viewing' machine (a sheet of card in which you have cut out a square or rectangular area criss-crossed with cotton thread to form squares) which you can hold up in front of you to view the original painting. From then on it is up to you to concentrate and work hard. If you are not able to arrange to work on the spot in an art gallery don't be deterred. You can always copy from reproductions in books – although the textural and tonal qualities never quite match the originals. The main advantage is that you will be able to work undisturbed.

10 A COLLECTION OF YOUR OWN

Having a
strategy for
looking and
buying

If you know anyone who has ever made home-made wines they will probably tell you that this seems to develop their taste for the real thing. They are not satisfied with inferior quality and gradually move on until they have tasted the very best. It is the same with painting. If you paint you inevitably appreciate more and more the superior work of outstanding artists. You experience intense pleasure when confronted by great works of art and it is only then that you sense the magnificence of human achievement through visual expression. We are lucky for we can visit large galleries where great works of art are housed, but we can also find it pleasurable to find one or two more modest works for ourselves.

If you ever intend to make a small collection of original old and/or modern paintings then you will need to have a strategy. Will you look in antique shops for 'finds', or do you intend to go to small private galleries where you could purchase all manner of styles at all manner of prices?

Will you hope, on the other hand, to obtain the services of an agent and get him to scout around for work by a favourite eighteenth-century painter? This can be very expensive of course, and only you can decide.

Antiques are becoming exorbitant in price, but there are many young painters who are willing to sell their modern works cheaply. What you need to do is to visit small, one-man exhibitions or group shows in local galleries. Ask the attendants or gallery directors for advice and, if possible, try to meet the exhibitors themselves. Their works will be given at a catalogue price but many will be only too pleased to bargain with you. You never know, you might have an up-and-coming star on your hands whose work is an investment. Having said this, I must admit that the

Rockpool. The author produced this large oil painting after studying the movements of water and sea-creatures on a beach.

important thing as far as I am concerned is that I must like what I am purchasing. Names and investments don't offer me much interest.

Hanging paintings in the home

The home reflects the interests and personality of its owner. If he is an artist then a stranger entering the house for the first time will know instinctively because of collections of objects and artefacts, furniture and colour schemes that he has a strong leaning towards beauty. The house can be the amateur artist's gallery: a place where he displays his sketches and paintings or the works of others that he has collected.

Let us consider the mounting and framing of paintings:

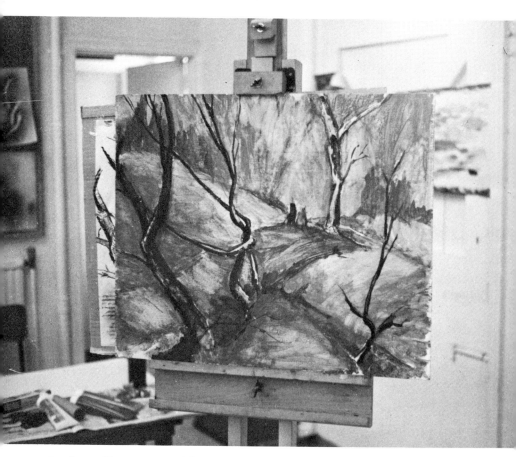

Landscape. First attempt at painting in oils, by an amateur artist.

1 The usual thing to do with a watercolour painting is to place it behind a picture-mount – a strong piece of card which has had a square or rectangular piece cut out – before it is put into a frame of wood and glass. Such a mount gives a painting space to breathe.

2 Oil paintings on canvas may be enclosed with a wooden moulding – there are various shapes and sizes of mouldings on sale and these are usually gilded or unpainted, varnished wood – whose corners need to be carefully mitred, glued and nailed.

I have made numerous improvised frames for my paintings but have found that the only way to achieve real satisfaction is to get a professional framer to do it for me. He has the necessary tools and expertise and will produce a first-class result which will invariably improve a painting as well as adding a touch of 'class'.

When it comes actually to hanging paintings on your

walls you would be advised to consider the background colour, lighting and pieces of furniture or bookshelves which are to stand close by. The background colour of the wall could be white but it might be useful to use a contrasting, dark colour so that your paintings read clearly against it. Such colour changes are easily achieved with household emulsion and a roller.

Groups of paintings can look well together. These can be placed one above the other or side by side; although groups of three or more pictures placed in different relationships might be what is needed. Just hammer masonry pins into the plaster, having first placed small pieces of masking tape on to the wall so that the plaster won't crumble away or fly out, and hang each painting by strong twine or wire. To complete the effect you can illuminate the paintings with discreetly placed spotlights.

LIST OF MATERIALS SUPPLIERS

National:
Binney and Smith Ltd., Amptill Road, Bedford, UK (and Madison Avenue, New York, USA).
Dryad, Northgates, Leicester.
Millers' Drawing Materials, Queens Street, Glasgow.
Reeves and Sons Ltd., Enfield, Middlesex.

Local:
Newsagents, Artists' Colourmen, Do-it-yourself shops, chain stores, etc.

Index

Personal Notes